ABANDONED
WASHINGTON DC

ABANDONED
WASHINGTON DC

THOMAS KENNING

AMERICA
THROUGH TIME®
ADDING COLOR TO AMERICAN HISTORY

America Through Time is an imprint of Fonthill Media LLC
www.through-time.com
office@through-time.com

Published by Arcadia Publishing by arrangement with Fonthill Media LLC
For all general information, please contact Arcadia Publishing:
Telephone: 843-853-2070
Fax: 843-853-0044
E-mail: sales@arcadiapublishing.com
For customer service and orders:
Toll-Free 1-888-313-2665

www.arcadiapublishing.com

First published 2018

Copyright © Thomas Kenning 2018

ISBN 978-1-63499-062-2

Typeset in Trade Gothic 10pt on 15pt
Printed and bound in England

PREFACE

The weight of history bears down upon the earth, the foundations of our present sinking deeper below the surface with each passing year. Our memories are a modified, imperfect form of the past, fractured and changed by the passage of time. Maybe some of our landmarks should be handed down in the same condition.

This book documents my modest efforts to explore disused, abandoned, and decaying structures in the Washington, DC metro area.

There's a thrill to be found in venturing to places we're not supposed to be. I'd be lying if I said that wasn't part of what draws me to urban exploration.

Seeking another side to the city that I call home—a mirror DC unimagined by the tourist throngs and rarely glimpsed even by native Washingtonians—I began to document the sites that fill these pages in the summer of 2011. DC is small, so I did, and still do, most of this adventuring on bike or on foot. To this day, whenever I need a quiet minute and a bit of perspective, I make my rounds.

So there are some adventure stories between these covers, as well as my favorite photos of abandoned DC. But maybe more to the point, I love urban exploration because it offers us the opportunity to meditate on some very fundamental questions about who we are—what it means to live in a city, all bunched up and sharing space with lots of other people, for example. How do we remember the past through its remnants in the cityscape around us? What kind of urban spaces do we aspire to inhabit in the future? More than a catalogue or even a guide, this volume is meant to be a meditation, examining the patterns of life, past and present, which undergird life in our nation's capital.

This isn't a guidebook, you will probably notice. For better or worse, a few of the sites featured in these pages are currently under redevelopment as part of DC's current real estate boom. Of the sites that remain in what we might call a state of nature, most, like the capitol columns, are marked clearly on tourist maps. Others, like the crumbling

edifice of the portico once supported by those columns, are a little trickier to reach, as strictly speaking, they are off limits to the public.

By way of encouragement to those determined to do their own exploration, know that there are enough pieces of the puzzle out there that each and every one of these ruins can be found without too much difficulty. I wouldn't want to spoil that riddle for anyone else, nor would I care to see these sites overrun by casual thrill seekers who might upset their blissful obscurity. Sadly, a steady flow of vandals and other questionable characters is already taking its toll at the former Forest Haven Mental Health Center, where there are now routine patrols by security guards.

If you do go visit these or any other decaying sites, remember that what you are doing is often of questionable legality and safety. I urge you to be careful, be respectful, take nothing but photos, and above all, tread lightly—leave things as you found them so that the next explorer can share that same thrill of discovery. While you are out there, open your eyes, open your ears, and open your mind—you'll be surprised at how stimulating some crumbling stone, broken glass, and rotting wood can be.

Go boldly!

May your explorations take you to the furthest reaches of yourself.

Thomas Kenning
March 2018

CONTENTS

1

AQUEDUCT BRIDGE ABUTMENT

The American landscape is littered with the detritus of failed commercial venture. Those who dream of becoming rich but who miss the mark, of making it with that one big idea that just doesn't catch fire, rarely have the wherewithal to clean up after themselves. The business of bygone Washington, DC lingers on in the form of vacant storefronts, idled industry, and in the abutment of the Aqueduct Bridge. Like a corpse stripped clean to pure white bone, it is enigmatic and therefore beautiful. Denuded of its historic functionality, it is a mystery to modern eyes, like the most whimsical design for a scenic riverfront park that you could ever dream.

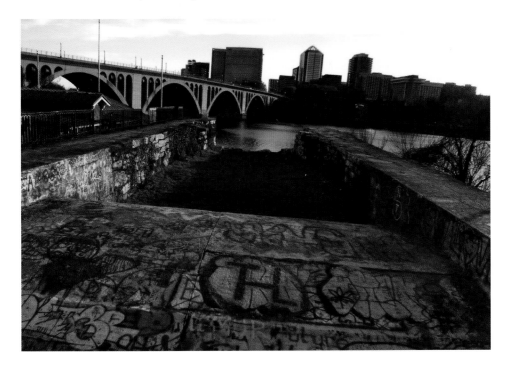

The Aqueduct Bridge dates to the golden age of American canals in the early decades of the nineteenth century. Back before the advent of the locomotive, water was the only economical way to transport goods through America's vast interior. Since the Potomac River isn't navigable much above Georgetown, some visionaries conceived of the Chesapeake and Ohio Canal—the river they wished that nature had made. This 185-mile wonder—dug 100% by hand—was to stretch all the way to the headwaters of the Ohio River, channeling the bounty of America's bread basket and the coal wealth of Appalachia into the pockets of eastern investors at the dawn of the capitalist age.

Naturally, the city fathers of Rosslyn over on the Virginia side of the Potomac River wanted a cut, too, and so was conceived the Aqueduct Bridge. This was no traditional bridge, but as the name suggests, it was a bridge of water over water, something that could only have made sense in a world of canals and rivers. Cargo coming down the C & O could be transferred across the river on the calm waters of the Aqueduct Bridge without ever leaving the flatboat. For various reasons—not the least of which was that canals were already on the verge of obsolescence as cutting-edge railroad technology became faster and more reliable—the canal and its Aqueduct Bridge extension, for-profit ventures both, never performed as expected. After several renovations and reinventions as a Civil War-era military supply line, a toll bridge, and a leaky sieve, the Aqueduct Bridge was finally demolished during the 1920s and 30s. That is, all except the abutment on the Georgetown side and a lone pier near the Virginia bank.

The surviving abutment lies out of sight from the main drag of M Street, right at a distance where most wandering tourists turn back, returning to the familiarity of such authentically Georgetown institutions as ye olde Urban Outfitters and Häagen-Dazs.

The Aqueduct Bridge stands just beneath the imposing staircase seen in *The Exorcist*, and in the morning, it literally lies in the shadow of its automobile-carrying successor, the Francis Scott Key Bridge. If you're approaching on foot from the east, though, don't wait until you've hit these landmarks to descend to the river bank, or you will find yourself stranded in the buzzing traffic of Canal Road—sidewalks and crosswalks start to disappear west of Key Bridge, and anyway, you'll be on the wrong side of the C & O Canal itself, with no way to cross.

I made this mistake on my first visit, dazed and a little crazed after braving the volley of Georgetown shoppers on M Street—all the ones from suburban America, where the car is king and for whom sharing a narrow, old-timey sidewalk is quite literally a skill they've never practiced before. The abutment is so close to the bustle of this world, and yet so far—isolated by a practical moat, in the form of the C & O.

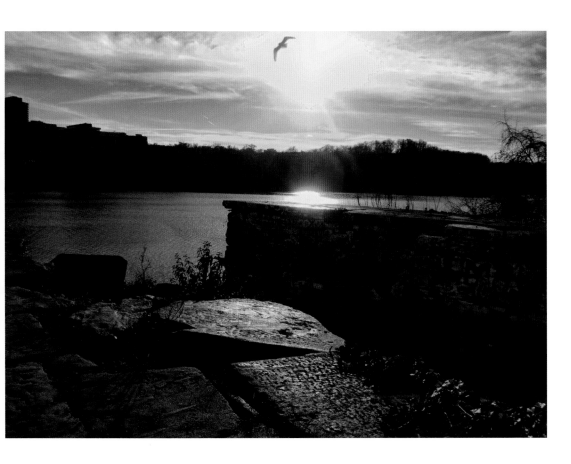

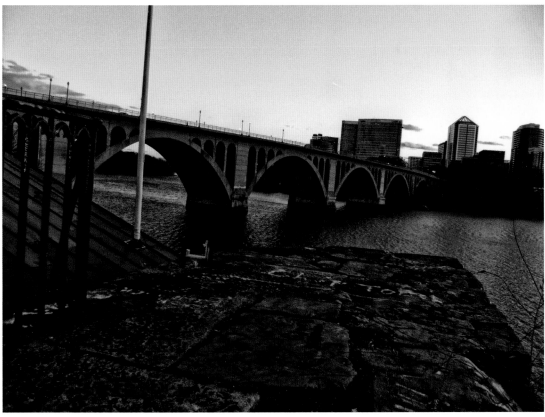

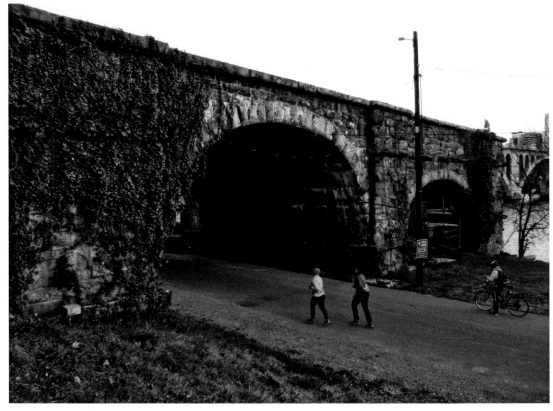

Finding myself on the north side of the canal—with the abutment in sight—separated by just a dozen tantalizing feet or so of murky, stagnant C & O water, I made the questionable decision to cross over the canal via the Key Bridge. Easy, except not. To do so from where I stood, I needed to scale the seven-foot-tall masonry embankment that keeps M Street from sliding into the Potomac itself. I attempted this, only to find my mighty leaps thwarted by a thick carpet of slippery wet leaves resting atop the retaining wall. Defeat.

So, I made an anticlimactic backtrack along the towpath for a more sensible crossing of the C & O via the pedestrian bridge. In minutes, I was hopping the rail that halfheartedly guards the abutment from noisome pedestrians and overly-inebriated Georgetown students. The solid stone masonry of another era frames a green lawn ripe for picnics, yoga, and dog poop. In other words, a perfectly usable and distinctive green space has been carved from that which is disused—a kind of down low High Line reclaimed by those in the know, a secret grassy pedestal where canal water was once channeled a few dozen feet above the Potomac.

I arrive at sunset on a winter afternoon, and there's a couple here, locked in a loving embrace twenty feet over the river. A professional photographer and his assistants circle, offering encouragement with greedy snaps of a camera's shutter. The Aqueduct Bridge abutment has become the ideal ruin for public consumption—safe enough for engagement photos and walking your dog. Frankly, it affords the best view of the Potomac I've ever seen.

It's an almost completely invisible monument to the busted future of two hundred years past, a future bypassed by the bustling traffic above, left to crumble and molder in peace below, an oasis of history in the midst of booming third millennium consumerism above.

Graffiti artists have assertively claimed the space for their own, and one tag that appears repeatedly and with great prominence during my visit reads, "The Clinic." As in, "for those who are weary and soulsick, threadbare and worn from the vehement monotony of modern life, for those who need some contemplative sojourn to another world, or to the ruins of one, at least."

I like to think that's what the artist was going to write, anyway, because if you stay long enough at sunset or sunrise, that aptly sums up how this place feels to me.

The guy probably just ran out of spray paint.

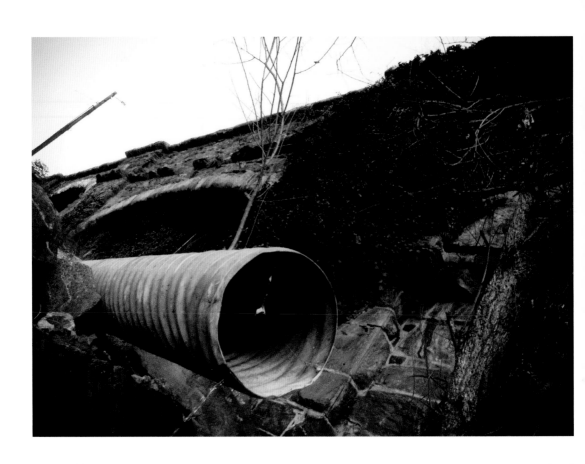

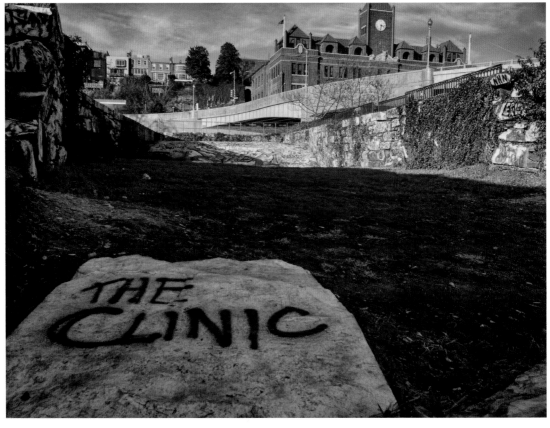

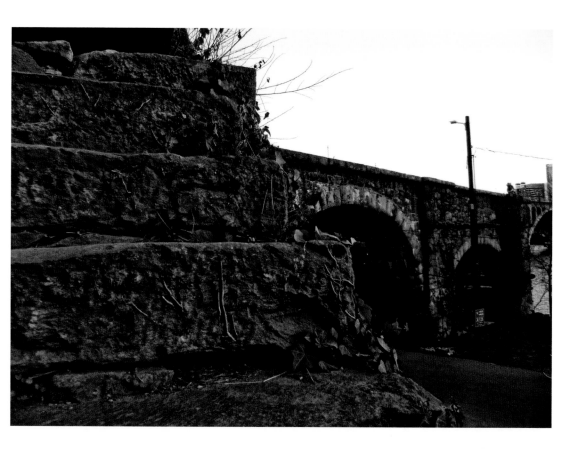

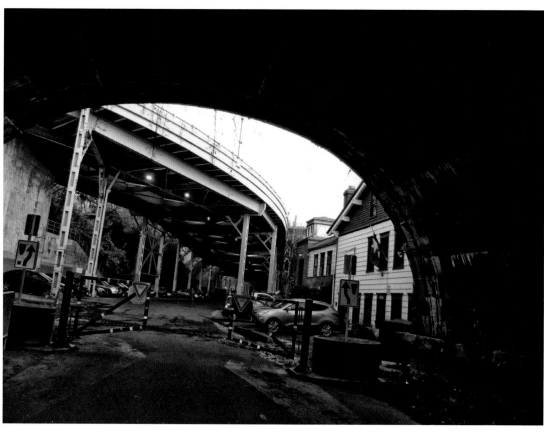

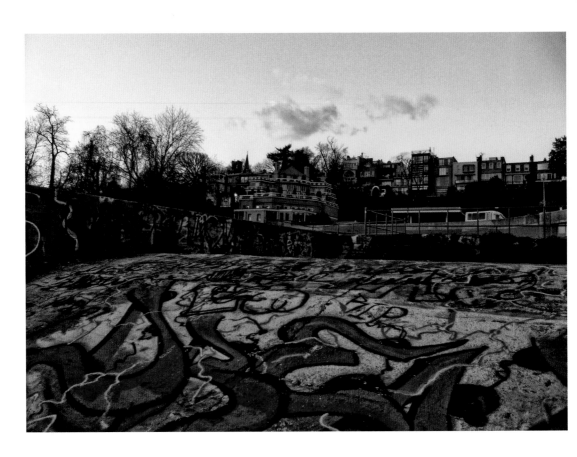

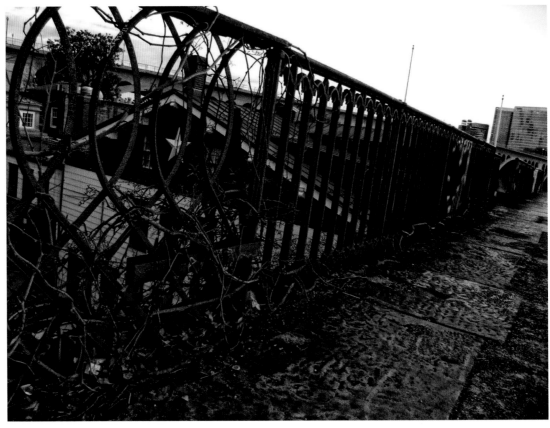

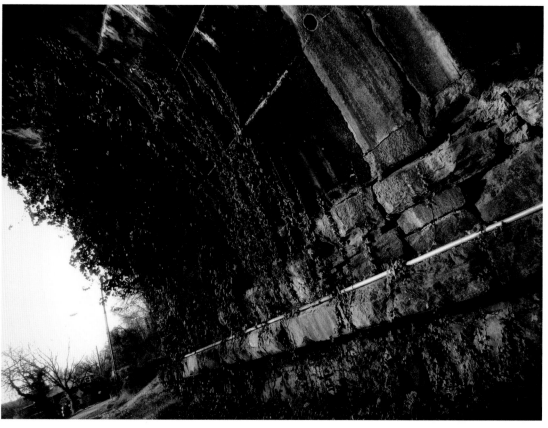

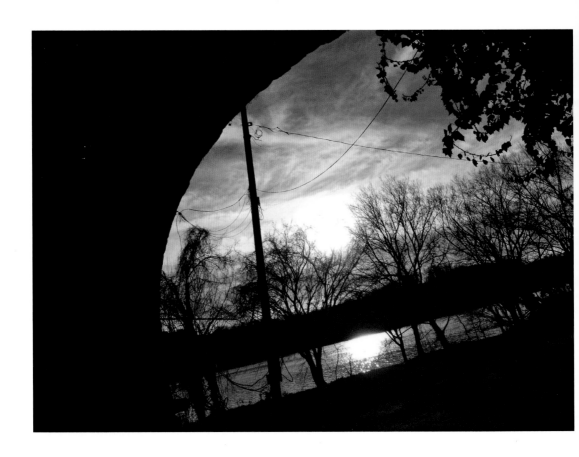

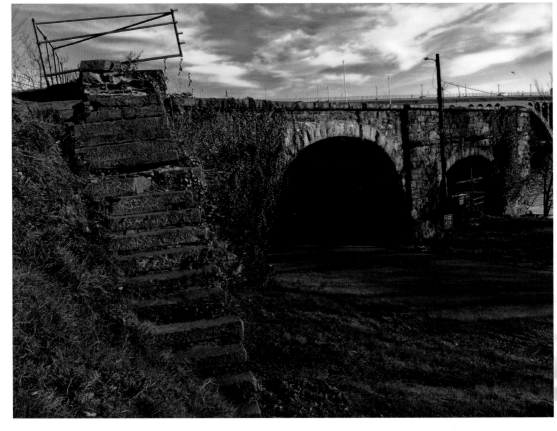

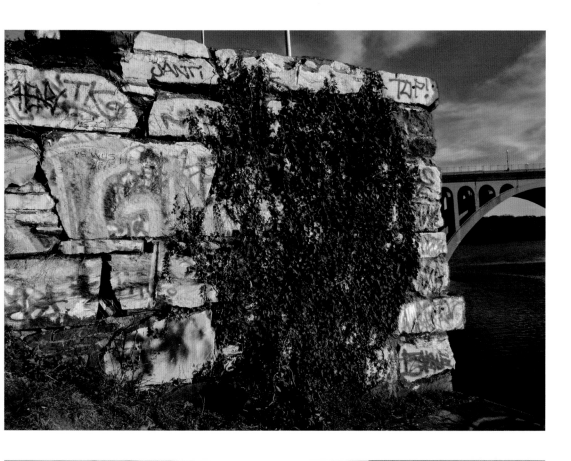
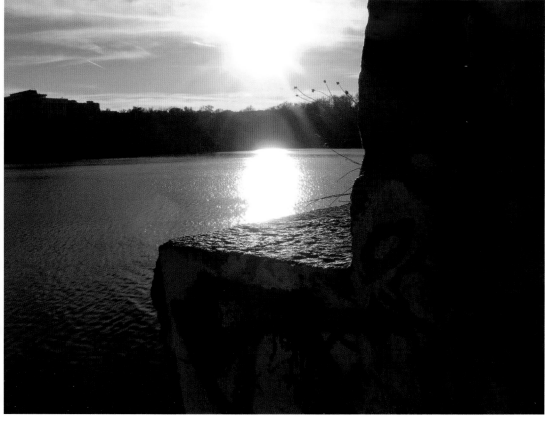

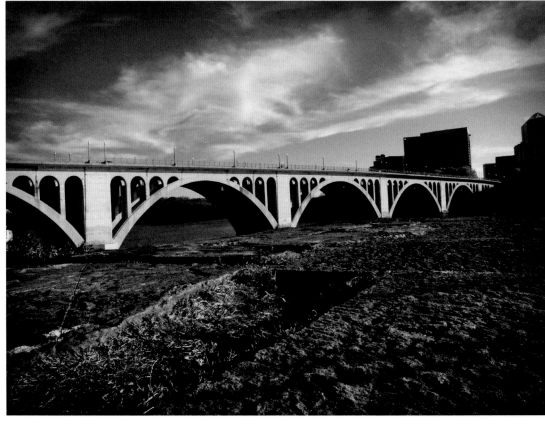

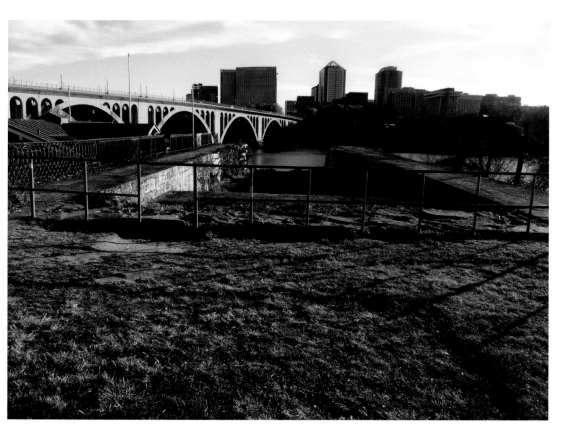

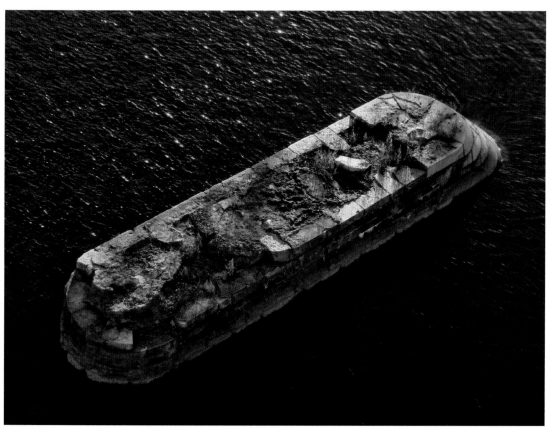

2

EAST PORTICO OF
THE US CAPITOL BUILDING

The remains of the east portico of the U.S. Capitol Building, scattered between Rock Creek Park and the National Arboretum, are historical relics—too significant just to throw away, but not quite nice enough anymore to put out on the front lawn for company to see.

There is a good chance that these ornate stones were handled by enslaved hands at some point in their production, incorporated without irony into a building meant to symbolize the glory of our fledgling democracy. Carved from Virginia sandstone in 1828 and built to stand the test of time, this neo-classical façade was intended to be the lofty republican ideal of a young nation made manifest.

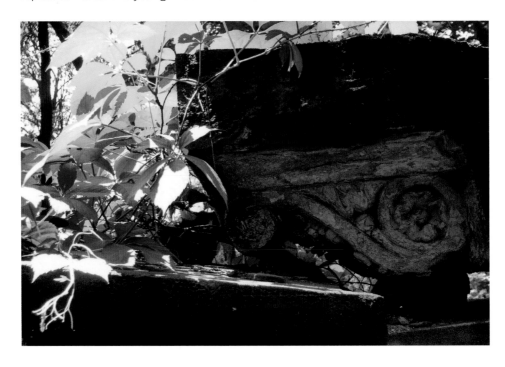

But like the nation itself, the U.S. Capitol Building has been a work in progress in fits and starts for more than two centuries. Time, taste, and the need to house representatives from a growing number of states resulted in a building the proportions of which its original architect could scarcely have imagined. The now-familiar capitol rotunda was completed in 1864, towering and truly monumental at 289 feet. This was a brash statement of confidence in the future for a nation rent at the time by civil war.

Evolution in democracy and design had left the original neo-classical columns and pediment out of proportion with the finished product. That finished dome dwarfed the original east portico, which now looked like a quaint remnant of the nation's preindustrial past. From afar, the Capitol Building made literal a common criticism of American government, both then and now—the whole thing had started to look a little too top-heavy.

A project to bring the scale of the portico in line with that of the rest of the structure was debated periodically over the years and finally executed in 1958. The east portico as it stands today—grand and seemingly of a piece with the rotunda—dates from this time. The historic remains of the original east portico—where presidents from Andrew Jackson to Dwight Eisenhower were inaugurated—were inauspiciously cast aside, disposed of, and fairly forgotten.

Foreseeing some unlikely scenario that today escapes me, someone in 1958 thought to assign a catalog number to each stone fragment that comprised the original east

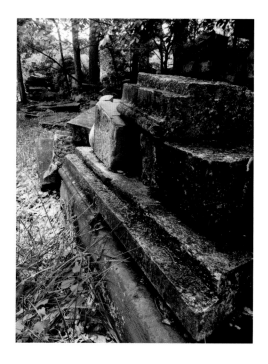

portico. These identifying marks remain etched conspicuously on interior edges of these otherwise inscrutable stones. Presumably there is a dusty set of instructions somewhere deep in the archives of the Architect of the Capitol. Like some gigantic puzzle, this thing could theoretically be reassembled someday, plus or minus a purloined piece or two that has made its way off as a souvenir over the years.

The remains of the old east portico reside today in Rock Creek Park, not far down the path from the horse stable, stacked carelessly with little more than a canopy of trees to shield them from the weather. Anonymous, with no marker and no fence, the fragments of the old portico are protected from thieves and vandals not by park police, but by virtue their own ungainly form. They are arresting in their decay—a meditation on the impermanence of even man's greatest schemes. The weight of history bears down upon these once august stones, and they sink an inch into the earth every decade or so. Woodland sounds fill the air. Moss grows on the edifice of representative democracy as it was originally conceived.

This is no movie set. These stones are cratered and pocked, worn with age, their expertly hewn faces dulled by two centuries of exposure, neither refinished nor refurbished to appear a minute newer than they are. In this ruin is encoded the passage of time, the very real partition between our experience in the present and that of the figures and events of our past. And so, paradoxically, these crumbling remains offer a more primal connection with the nation's history than some of the more contrived monuments downtown.

Take Abraham Lincoln, for example, whose memorial on the National Mall is a product of the 1910s. It is historical for many reasons, none of which has any direct connection with Lincoln the man. But Lincoln himself knew *these* stones, this fragmented facade of the east portico. During the 1840s, he walked past them on his way to work in the House of Representatives. In the 1860s, they bore witness as he took the solemn oath of office for the presidency, not once but twice.

In many ways, the crumbling facade of a building is a much more immediate and visceral testament to the past than is a Walt Disney-style recreation, an animatronic man of our time. Abraham Lincoln the man, like the ruins of the Capitol's east portico, stands 150 years removed from the present. That passage of time is important when trying to understand him. The imagineered animatronic Lincoln—Spielberg's *Lincoln* or the Lincoln seen on the National Mall in DC—creates the false and ultimately misleading sense of intimacy, telling us more about what Hollywood thinks of Lincoln, or what the builders of the Lincoln Memorial in the 1920s thought of Lincoln, than what his contemporaries thought of him.

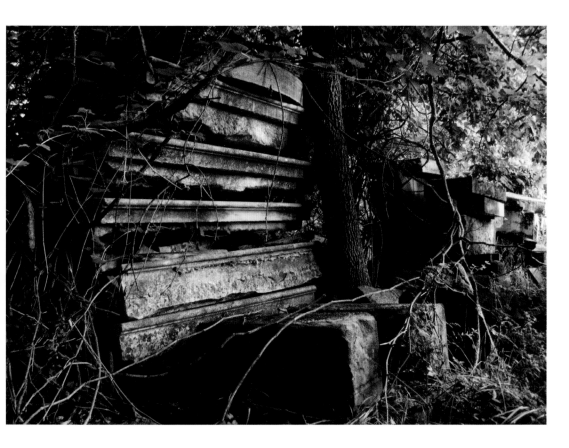

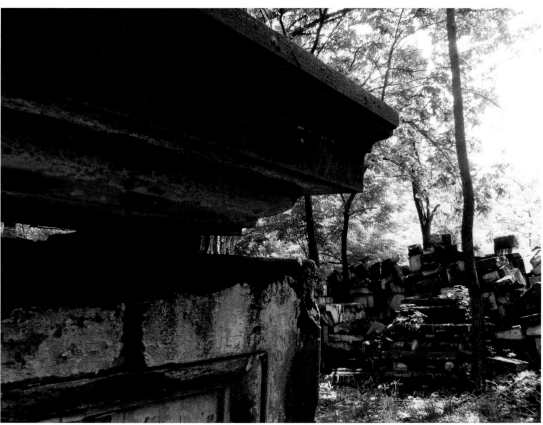

Give me the crumbling superstructure of a real past to its plaster facsimile any day.

Here in the purgatory of Rock Creek Park, you can take as many photos as you like. Run your hands over their blemished surfaces. Rest on them, askew as they may be. Sit in their midst, in the shade of the park. Contemplate our nation and your place in it. In utter silence and solitude.

There is a certain order in decay. It is an order more inexorable than man's feeble attempts to shape the world with his hands. Decay lays bare the futility in man's arrangements of steel, wood, and stone, his efforts to build a fanciful roof over his head in celebration of his own glory, to manipulate his hostile environment after his own image. Decay, in effect, is a reminder of man's own mortality, his own brief cameo in the ongoing serial of geological time. And it is for this reason that men so often despise the old—the ruined—as unpresentable and undesirable.

But if we are willing to slow down—to sit amongst these stones—we can understand our ruins another way. Urban decay is the process by which the indoors become, in halting, sometimes dramatic steps, the outdoors. It is the convergence of the will of man and the order of nature. Whether it takes years or centuries—without the constant and continuous intervention of man on behalf of his creations—the latter wins out every time. These ruins are all around us, where the developer has yet to insert himself, and, just like other recognized national treasures—like the Grand Canyon—the demolished remnants of the east portico should be seen as an expression of natural beauty.

These ruins beg the curious to explore them, but they simultaneously and necessarily ask us to hold our history at a dispassionate arm's length—to account also for the time and events which have transpired in the interim. In truth, Lincoln, transported miraculously through time, would find the twenty-first century as bewildering as I would find the nineteenth.

And in that spirit, perhaps the truest memorials should reflect the time that has transpired between the past and the present. A historical structure preserved and presented as a museum or some kind of curio is a platitude, a serviceable form of entertainment in which our contemporaries do the work of interpreting the past. This is often done in a way that makes it seem to some degree like the present, as if the audience were experiencing "history" themselves. These so-called experts in historical interpretation are often afraid of boring you or offending you with the dust of the past—they are entertainers.

Urban exploration is DIY history. It asks its practitioners to reflect on the passage of time—what has changed, what has stayed the same. It offers the chance to cut out the curator, the eulogizer, all those arbiters of the past who, as well-intentioned as they may

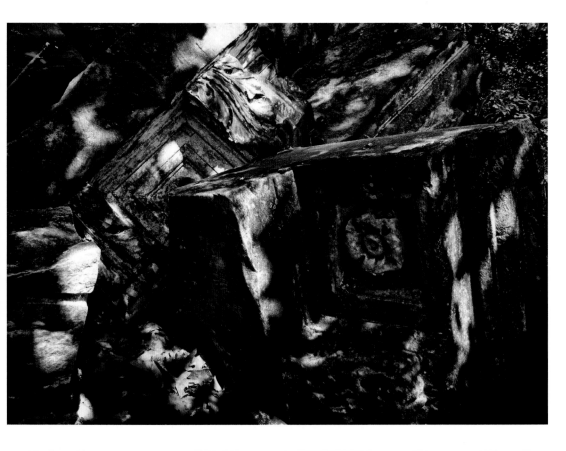

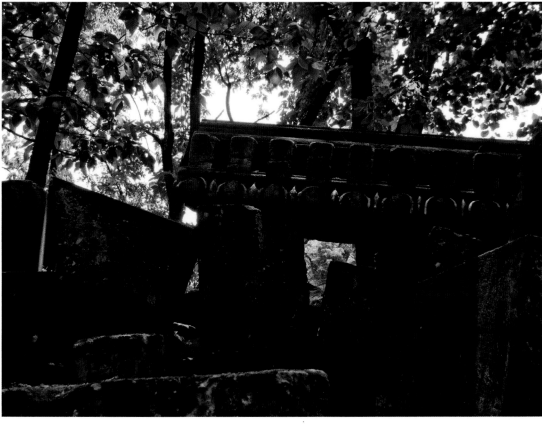

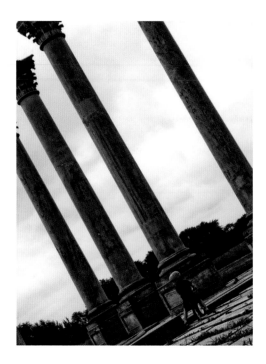

be, refocus the past through an incomplete, modernist lens in an attempt to curry the favor of those with the shortest attention spans.

When you stand beside a faltering ruin, you become the historian. You stand on the far end of a continuum, facing the period and the people you hope to understand. In the real world, Lincoln's legacy is complicated, inextricable from the events that have transpired since. If we spend less energy producing a tidy experience of history, in the process collapsing the very real distance between our circumstances and theirs, our historical sites might just be more authentic, more honest, and more evocative of their period as it stands in relation to the present.

We can learn something from nagging bits of history like the east portico—the ones that confuse and confound, that are too significant to throw away, but which don't fit in with the latest remodel on our present.

Meanwhile, twenty-two of the twenty-four capitol columns that once comprised the east portico reside in the National Arboretum across town, rescued by activist Ethel Garrett from similar obscurity. In 1958, after the east portico was demolished and expanded to its current proportions, these now miniature columns were discarded in an inglorious pile, strewn and abandoned on the banks of the Potomac. Like any number of things in your own closet, Congress regarded them as important enough to keep, but could not conceive of a purpose for them. Ms. Garett thought this was a shame. She lobbied to move them to their current home, as a featured attraction in the National Arboretum.

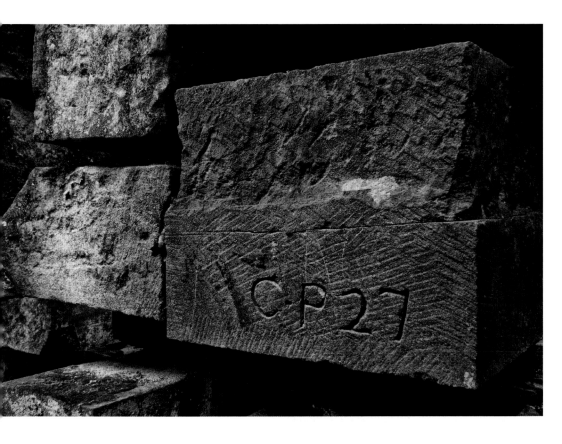

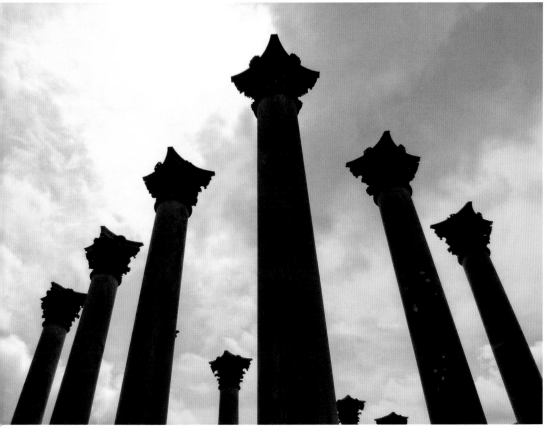

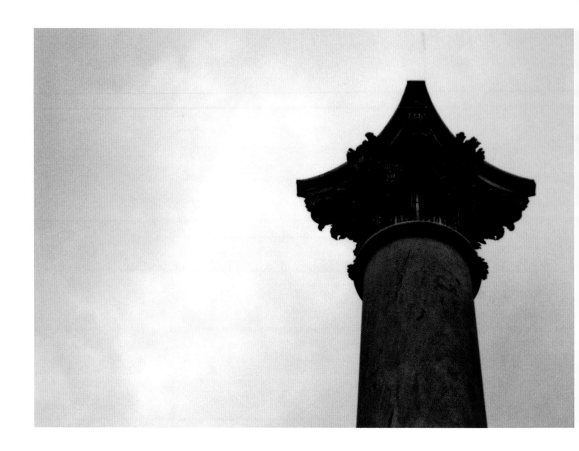

These columns are the rare DC ruin marketed to tourists, but they're so far from downtown. The thin crowds that they draw add to their inscrutability.

Something important seems to have happened here—except, it wasn't here that the thing happened.

A mystical temple. Thrust gloriously skyward. Supporting the dome of the sky. Celebrating some unspecified ideal. The effect is evocative and stirring—if a bit perplexing.

They make for a nice photo, though, and sometimes that alone is worth the trip.

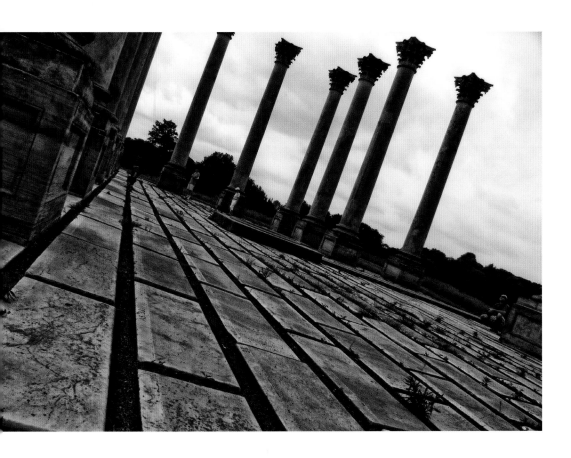

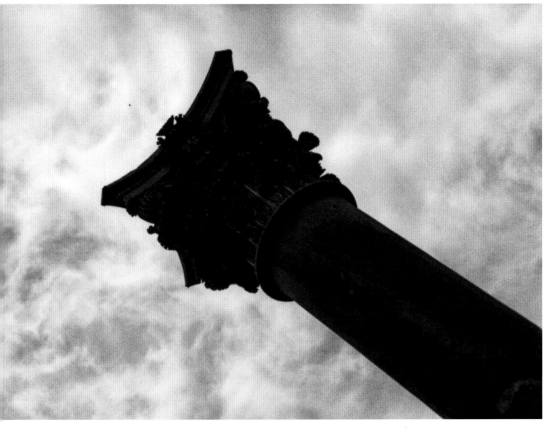

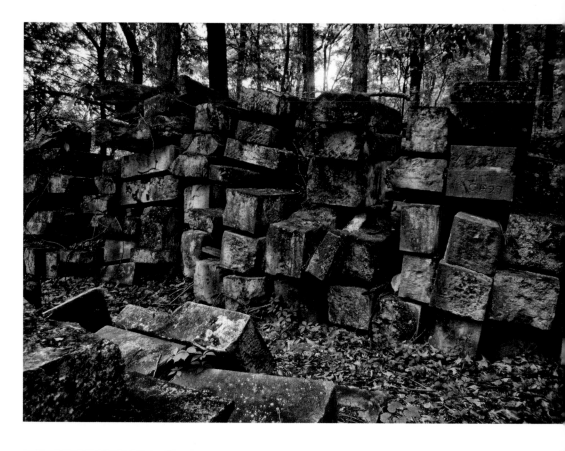

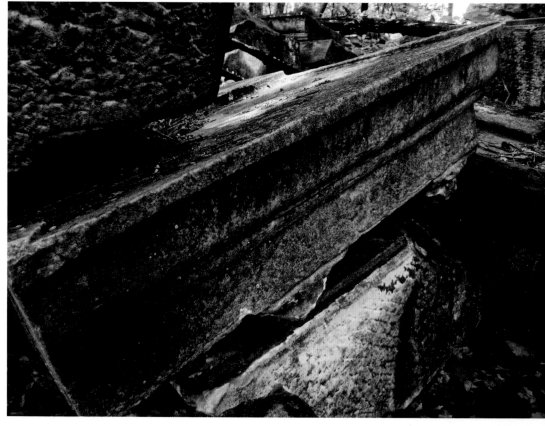

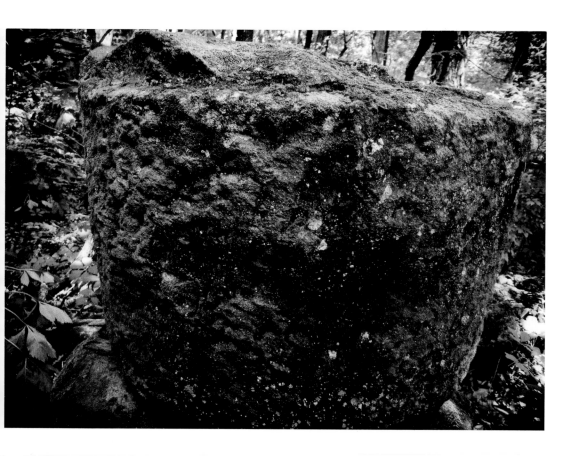
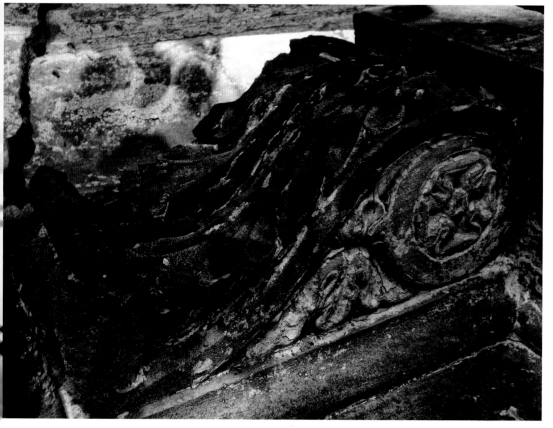

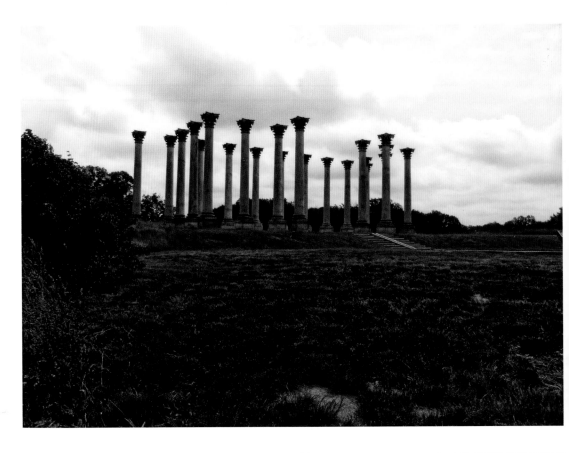

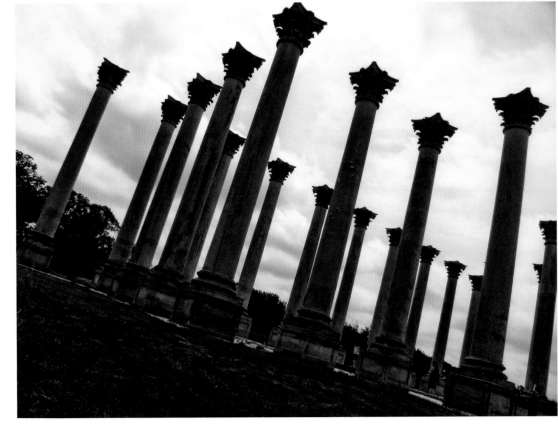

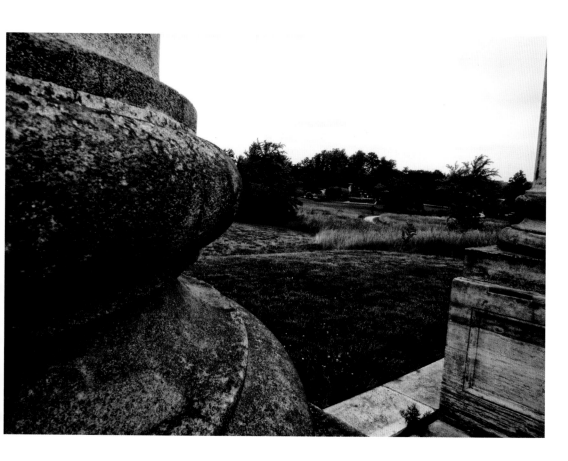

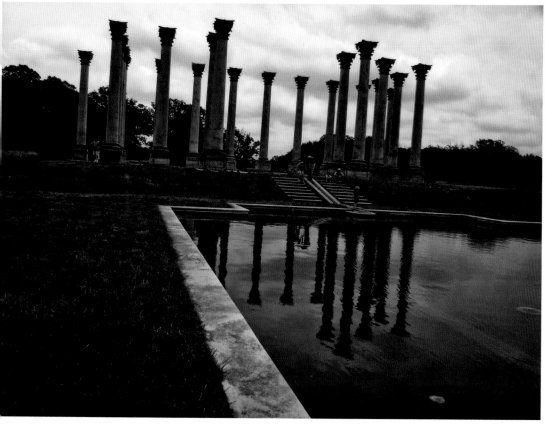

3

FOREST GLEN SEMINARY

T he ad copy on these newly subdivided condos should read, "Witness the virulent creep of gentrification in action at historic® Forest Glen Seminary. While it lasts. Because gentrification is like a cancer—it will take over until there is nothing else left." Vacant, ramshackle dormitories and crumbling school buildings intermingle with brand new luxury condominiums, offering vagrants and investors the unique opportunity to get cozy as neighbors, all within earshot of the beltway. But then, Forest Glen has been a bit of a potluck, pragmatic proposition since its inception in 1887.

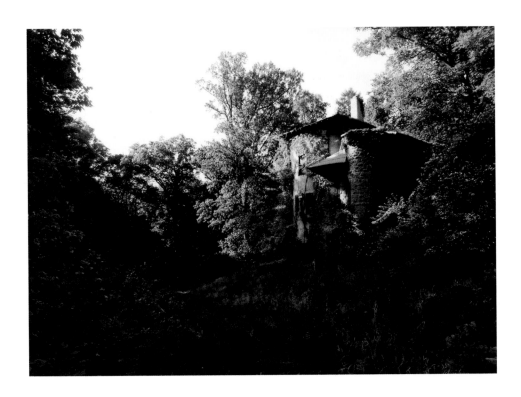

Forest Glen began life in as a luxury hotel—Ye Forest Inne, to be precise—a summer resort catering to wealthy guests from the nation's capital. Even though it predated the beltway and suburban sprawl by a generation or so, the idea of getting away from it all so close to home didn't go anywhere—why stay when the railroads made it easier than ever before to go on a real vacation?

So DC's elite were not interested in spending time at Forest Glen themselves, but what about getting some peace and quiet by sending their kids there? On this logic, the inn underwent the first in a series of dramatic reinventions, becoming an all-girls finishing school known as the National Park Seminary. The most dramatic and eclectic architecture on the site, by turns reminiscent of fairy tale cottages and Chinese gabled roofs, dates to this period. While National Park Seminary was successful for some time, a double whammy of the Great Depression and shifting social norms meant that by the end of the 1930s, the school's heyday had long since passed.

During World War II, Forest Glen was appropriated by the U.S. Army and used as a retreat for convalescent soldiers, a sort of annex for the nearby Walter Reed Medical Center. It fell completely into disuse and disrepair in the last quarter of the twentieth century, until the Army finally divested itself of the property in the early 2000s. By this point, once bucolic Forest Glen was hemmed in on all sides by residential, government, and commercial development. In short, building condos here would be the next best thing to a license for printing money. Developers were eager to realize the real estate potential of the land, but a group of local enthusiasts have been vocal (and litigious) in their quest to maintain the historical integrity of the site.

The result is a peculiar tension between the old and the new, the desiccated and the debutant, the waning and waxing money of America. The ghosts of a dead elite, who flaunted their status by enrolling their daughters at National Park Seminary, skulk amongst the blessed yuppies of the twenty-first century who pay big bucks to reside at Forest Glen. The quirk and charm of this place is now a point of pride to those who can secure a loan large enough to live here … to huff the vapors of prestige off the leftovers of that old money investment, when wealth could build something special and not just mass produce the illusion of it.

Walking the remains one spring day, I found myself pondering deeper questions than the developers of this "historic housing opportunity" probably ever intended. What price (both monetary and philosophical) are we willing to pay to conserve and renovate historic buildings? Where is the tipping point between authentic nineteenth-century construction and something that may as well be a new building? Which bucket of paint or replacement

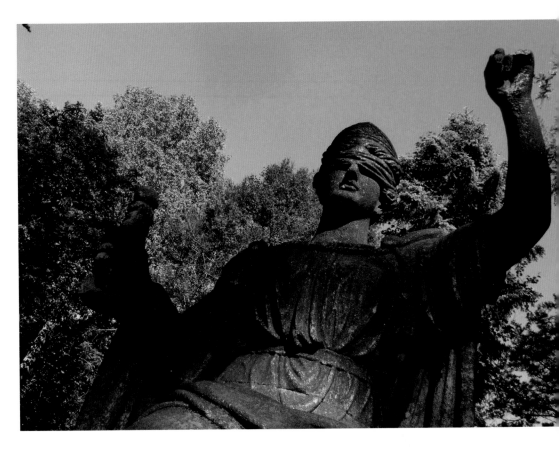

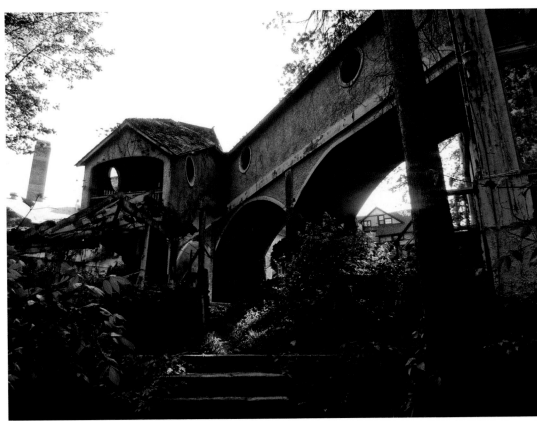

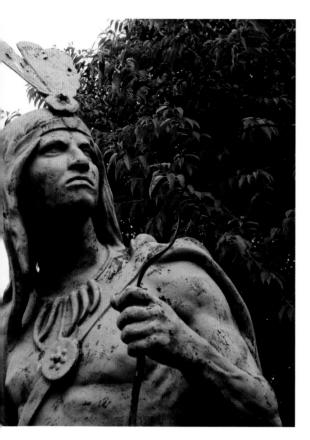
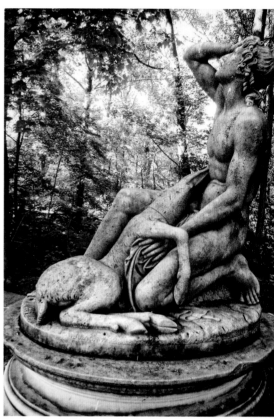

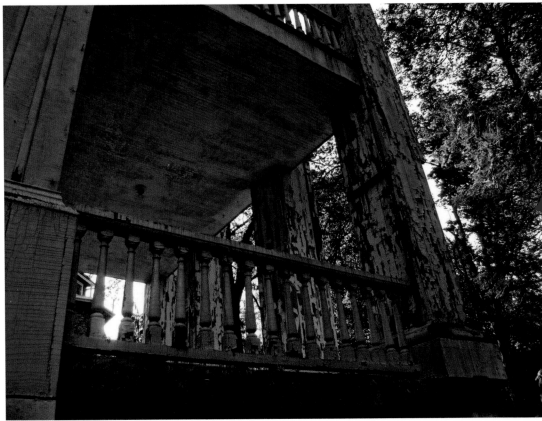

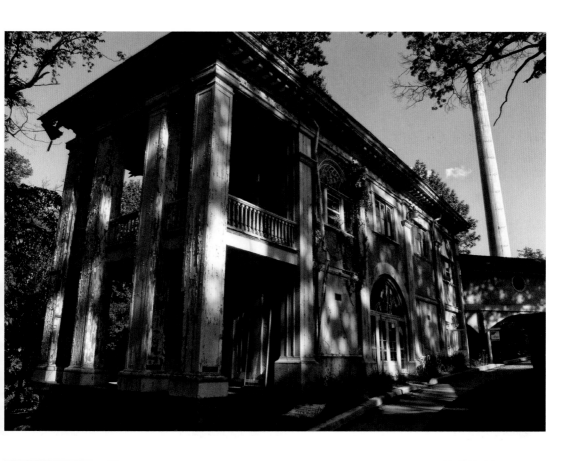

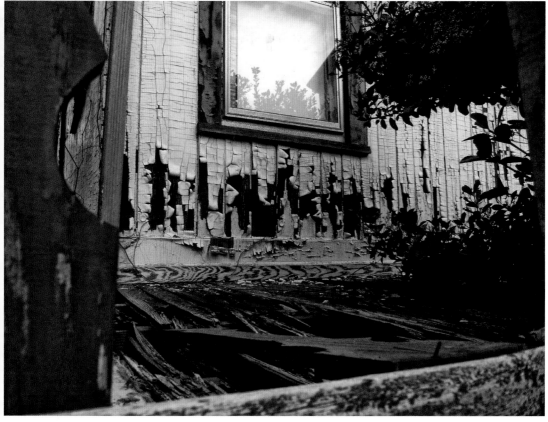

floorboard tips that scale? Is it the modern cable hook-ups that make it too twenty-first century, or is it the sign out in front, there to declare for those unwashed and uninitiated visitors that they are indeed looking at something "historic"?

This is a great site that bears repeat visits, for now at least, revealing something new each time—another statue in the woods, another cracked window into which I might peep, a snake crawling across the back of my hand while I scale one of these crumbling rock walls, or another explorer with a kernel of insight to share. Each time I have been, though, there are further signs of renovation and development. Check it out while it's still halfway weird.

For the record, the actual ad copy for National Park Seminary Condominiums reads:

NEW PRICING: Condominiums from the low $400s
PRIME LOCATION: Inside the Beltway, 1 mile from Forest Glen Metro
HIGH-END FINISHES: Hardwood floors, granite countertops, stainless steel appliances
HISTORIC FEATURES (per plan): Decorative fireplaces, wainscoting, crown molding
ABUNDANT GREENSPACE: On 13-acre glen, adjacent to Rock Creek Park

Units still available.

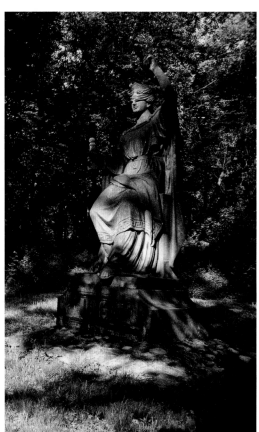
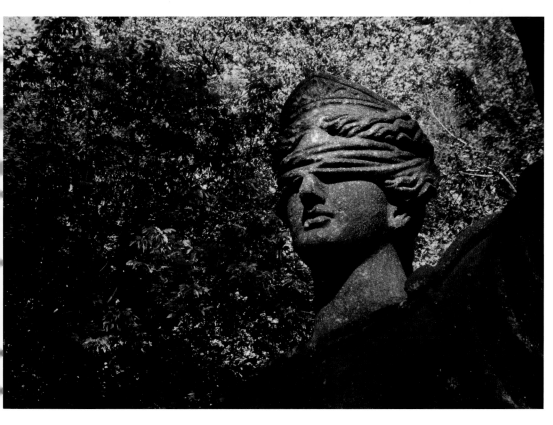

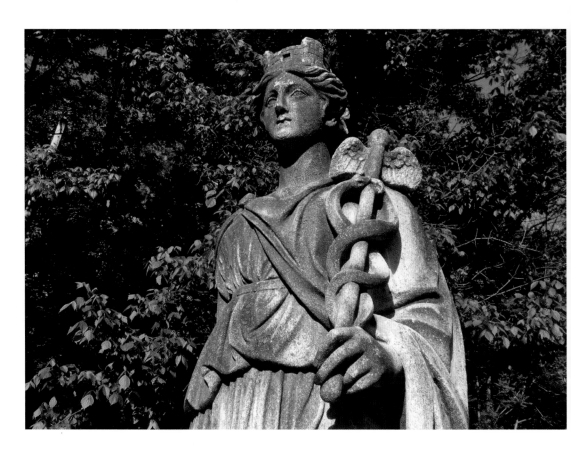

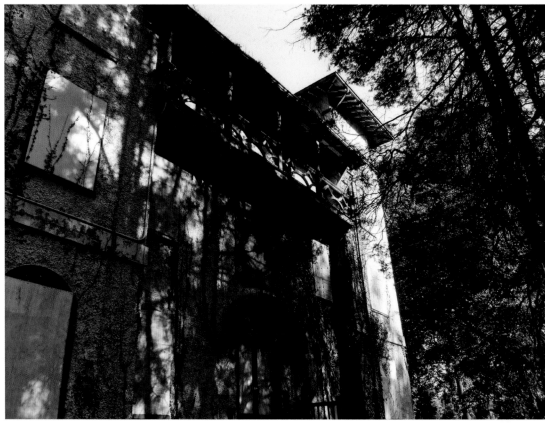

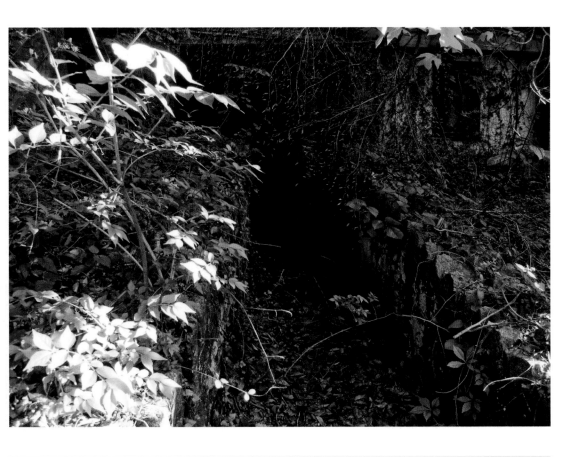

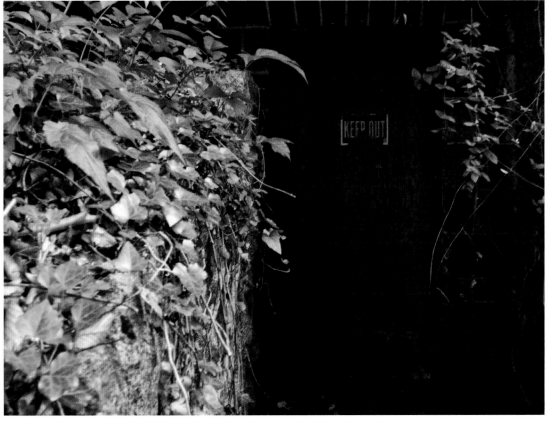

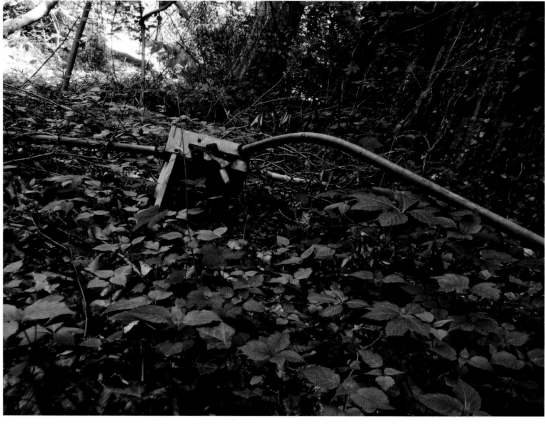

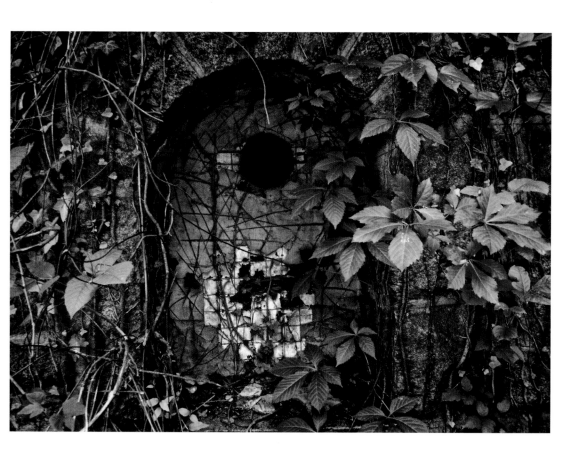

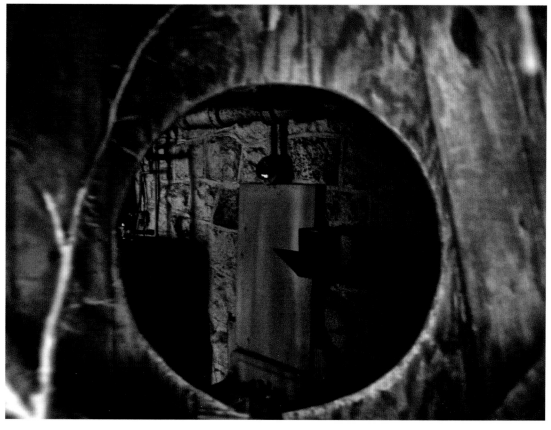

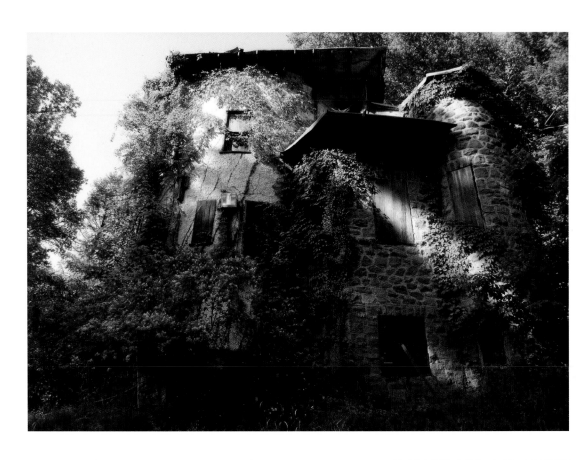

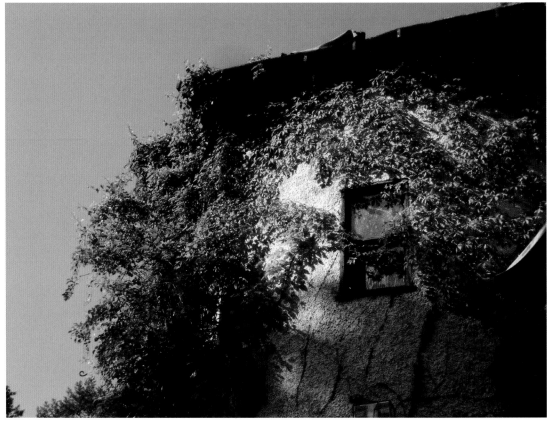

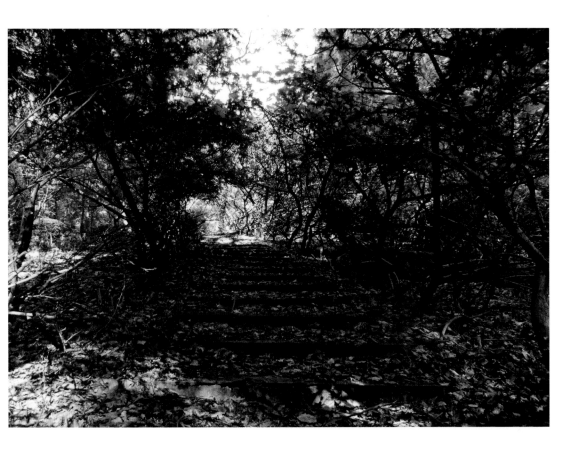

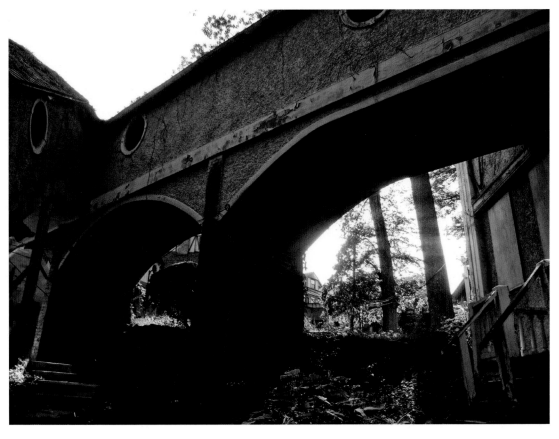

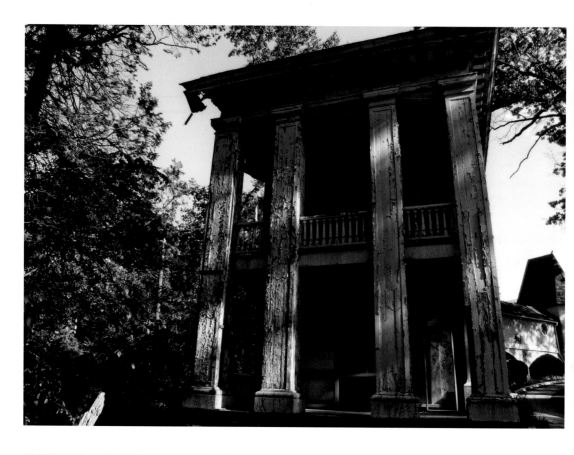

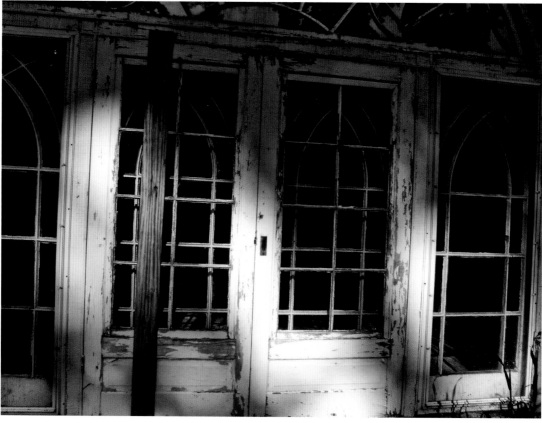

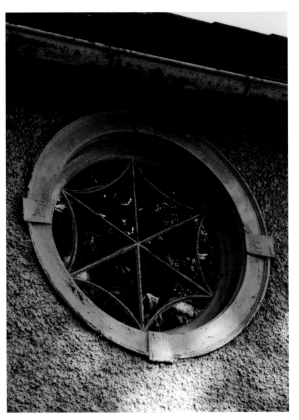

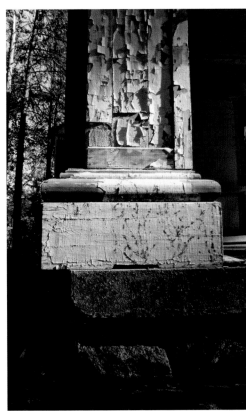

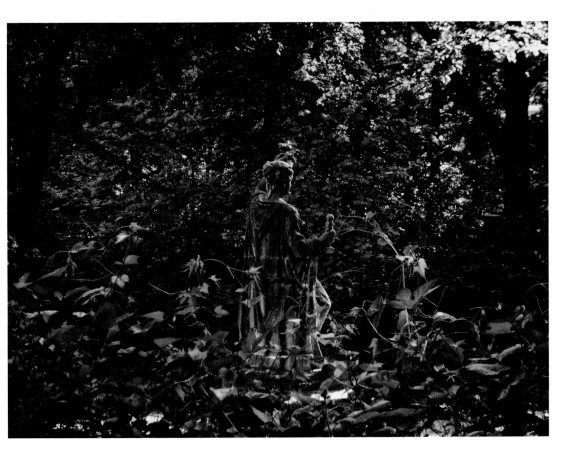

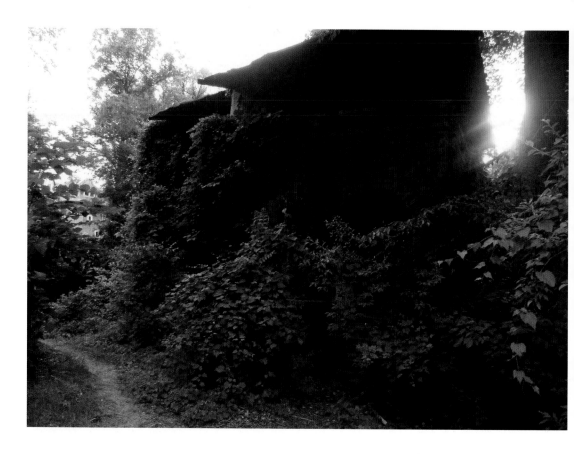

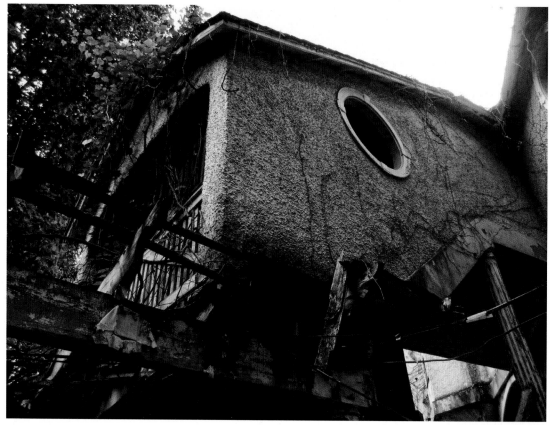

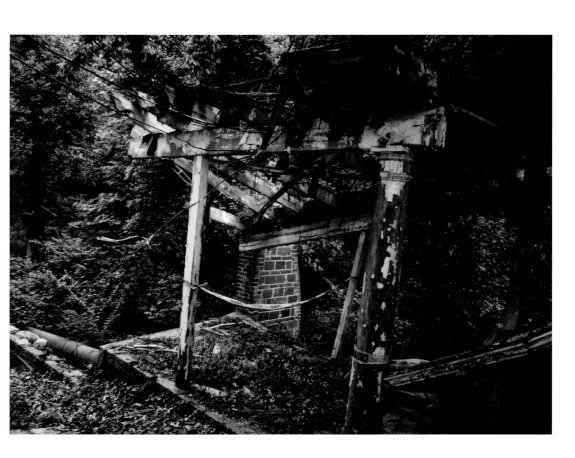

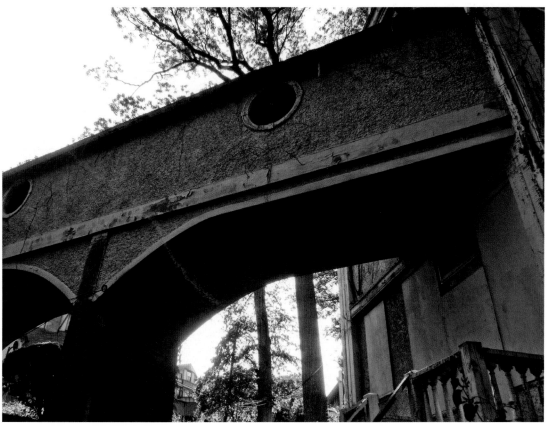

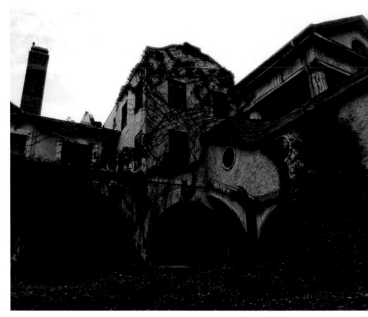

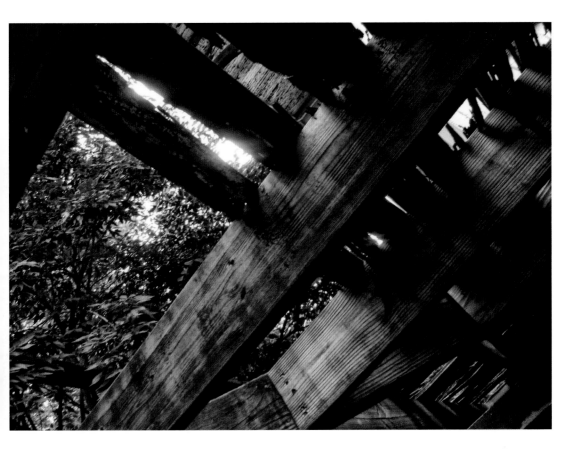

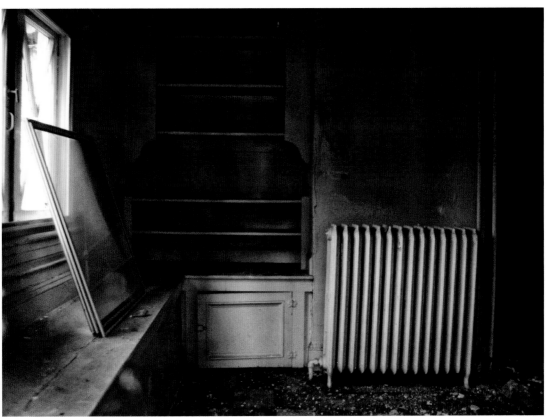

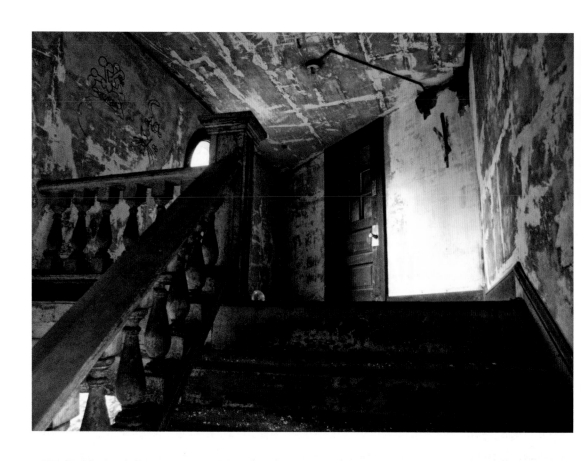

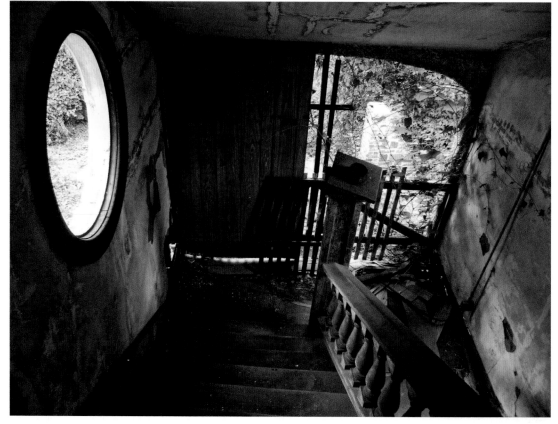

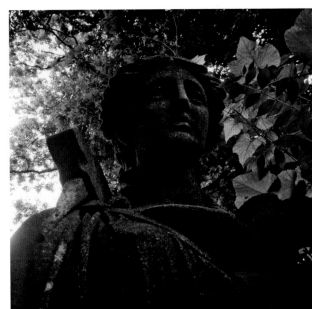
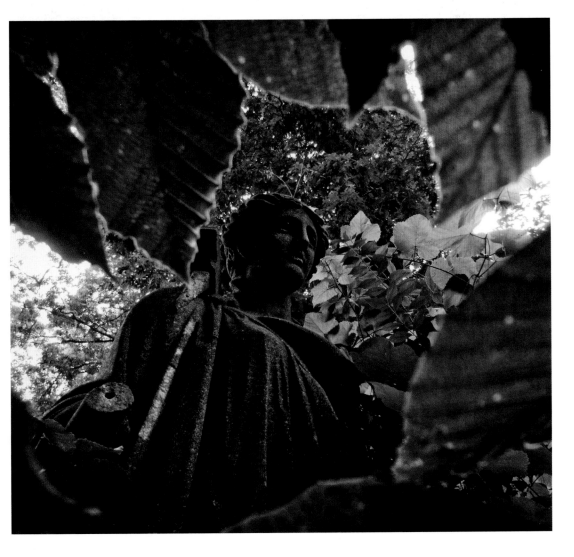

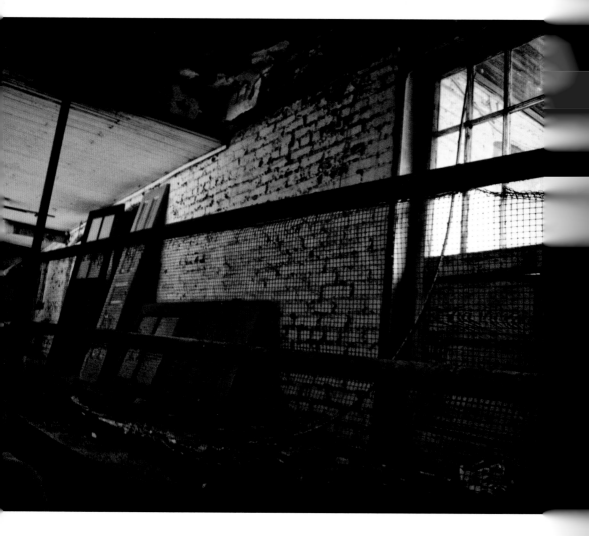

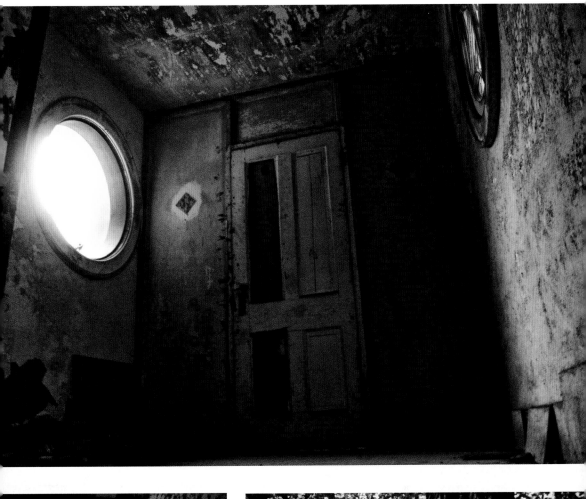

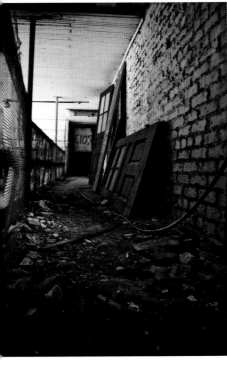

4

FOREST HAVEN MENTAL HEALTH CENTER

When that airy but not-so-distant music came drifting in on the thick evening breeze, we all froze. Chills like it wasn't June, but December. The tune was upbeat, with a female singer, but echoing through the vacant buildings around us, it rang of dread and menace. Moments ago, the only sound had been the glass shards crunching between our sneakers and the cement floor. But now …

Why would anyone else be out here, and why in hell would they be listening to Top 40?

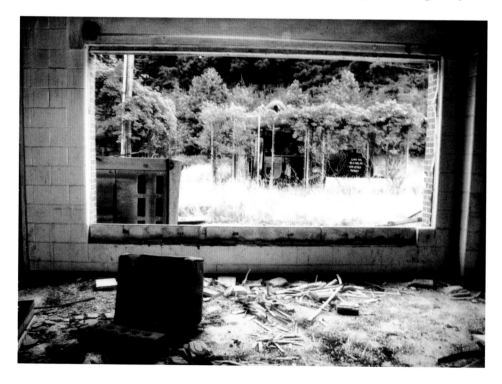

There are lots of reasons we shouldn't have been exploring the abandoned Forest Haven Mental Health Center. Lots of things that could make our visit dangerous. I'd run down a thorough list of possibilities with my companions even before we left DC—deterioration that could cause instability in a structure that's been abandoned for twenty years; guards charged with confronting trespassers on what is, in point of fact, government property; homeless persons seeking shelter in the catacomb-like expanse of the Forest Haven complex. Homeless persons who could behave irrationally or even violently if surprised in their solitude … And just for the superstitious amongst us, I added the threat of torment and torture at the malevolent whims of the lost souls who once called Forest Haven Mental Health Center their own personal hell.

But Katy Perry emanating distinctly from everywhere and nowhere all at once didn't seem to neatly fit any threat on that list. Our hearts pounded like heavy metal drummers. We waited for a bit, then decided to proceed, but our exploration was considerably more subdued from that point on.

I don't even remember when the music stopped. After a while, we just didn't notice it anymore, and it was gone.

That's the closest thing to a ghost story that I have to share from my first visit to Forest Haven Mental Health Center, which was shut down by a 1991 court order on charges of systemic abuse and negligence.

And that gets to the heart of the real horror. It is not some music, which is embarrassingly *Scooby-Doo* when you get right down to it. For me, urban exploration is a lark. I can leave any time I want. I can go home when a place gets to be too much. Or when it gets dark, and I get too scared to stick around.

The mentally disabled residents of the District—the patients of Forest Haven—had nowhere else to go when things got dark. This was home, whether they liked it or not. Or prison. Unlike me, they couldn't run back through the woods to the safety of a waiting car. They had no alternatives, and until the very end, too few champions. And they most definitely had something to be scared of.

On January 12, 1990, *The Washington Post* offered a glimpse into what went wrong at Forest Haven, reporting, "A 31-year-old male resident of Forest Haven, the District's center for mentally retarded adults, died Wednesday, becoming at least the sixth resident to die at the Laurel facility since May."

That's one digitally-retrieved death in a long string of men and women who died here, which is bad enough. But think about all of those who suffered here and still carry the traumatic memories of abuse and neglect—many of those folks are floating around

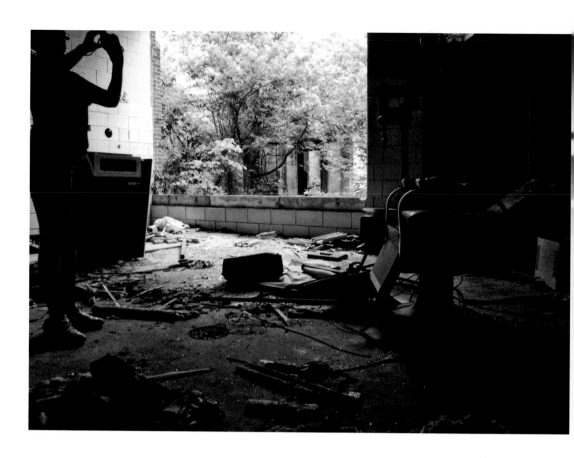

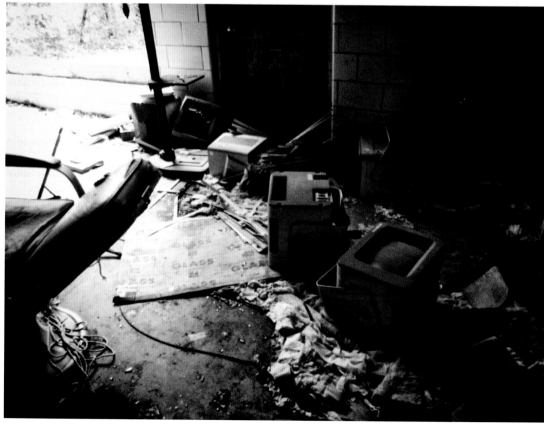

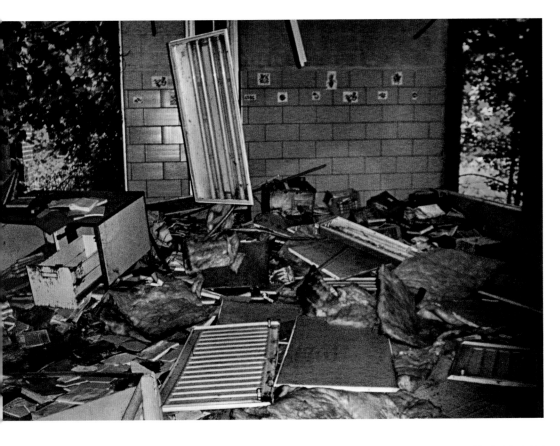

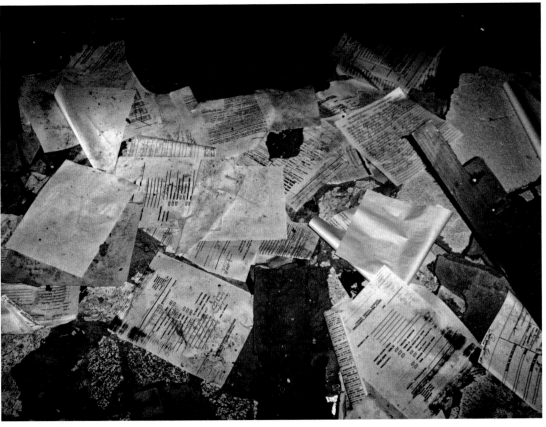

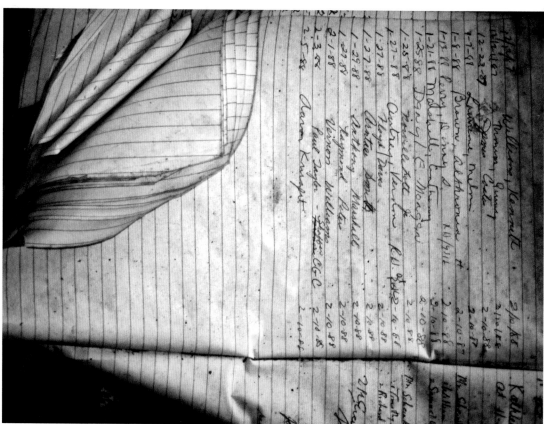

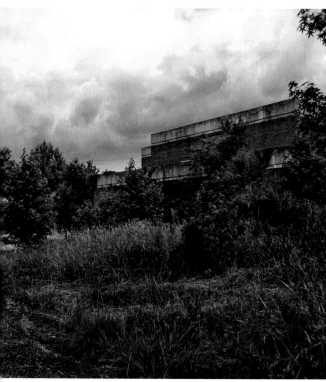

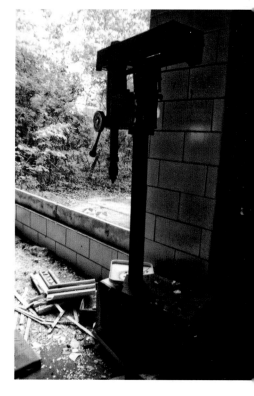

DC today. Abandoned, in a sense, long before the building. I don't know who that man from the *Post* article was, but I might be able to figure it out by rifling through the patient files that still lay strewn about the floors of Forest Haven. There's a fair amount of private-seeming, official-looking papers out there—cast aside like the patients whose conditions and treatments they document.

It really seems like they just shut the doors and turned off the lights on the day that court order came down. There are even dirty dishes in the kitchen, like some caregiver took their last break, set their coffee cup down, and headed home, not knowing that this place would be shuttered at the end of their shift.

The tall windows here have all been blasted out, probably by vandals. The furniture remains, covered in dust, mildew, and shards of glass. Some of it is banal office furnishing, but other items are shocking in their bluntness—man-sized metal cribs, rolling hospital beds, a sadistic apparatus that could be used either for esoteric dental procedures or electroshock therapy.

It's an adventure when you first get here, in spite of—and maybe even because of—that haunting music. It feels like a Hollywood movie where you see just enough blood and guts to make you squirm, but never enough to be truly shaken. Real life is always much gorier.

If you let it, though, this building affords those who dare to enter it the opportunity to reflect on the true meaning of horror—the way that we treat the weakest among us.

The way that we treat the weakest among us …

I've heard it said that that is one way you can judge a man's character, so why not a whole society's?

Walking from room to room, you get the feeling that you are last survivor of some horrible, cataclysmic conflict, one which resulted in the utter annihilation of mankind and all his decency. That you are alone at the end of civilization. It could have been atomic bombs that shattered these windows and burnt this building to a charred ruin. But it wasn't. Whatever happened here was more subtle than that, even if it was no less evil.

Though if this was what civilization had to offer, you wouldn't be too upset at its passing.

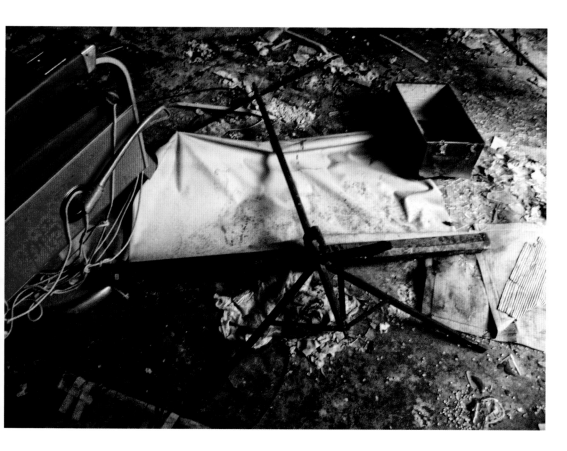

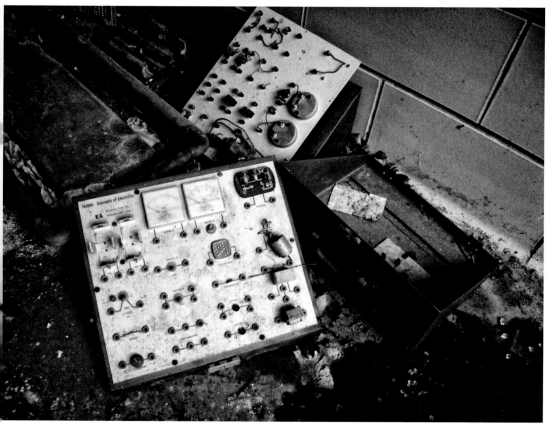

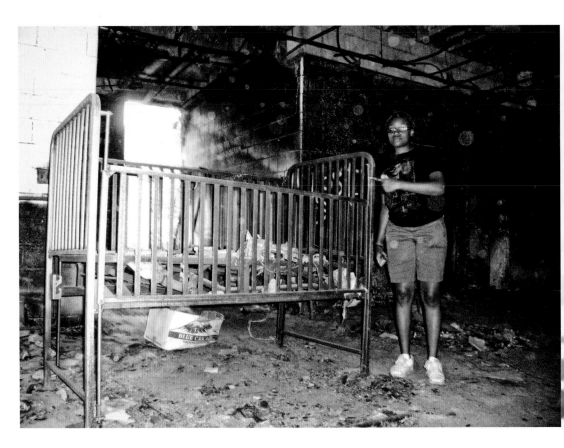

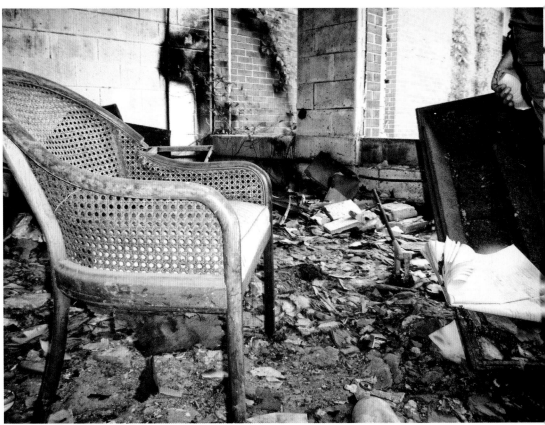

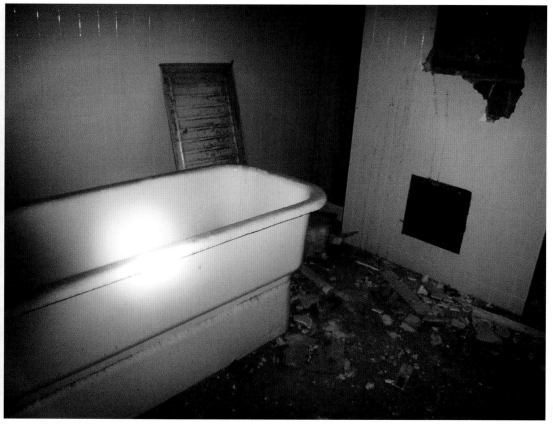

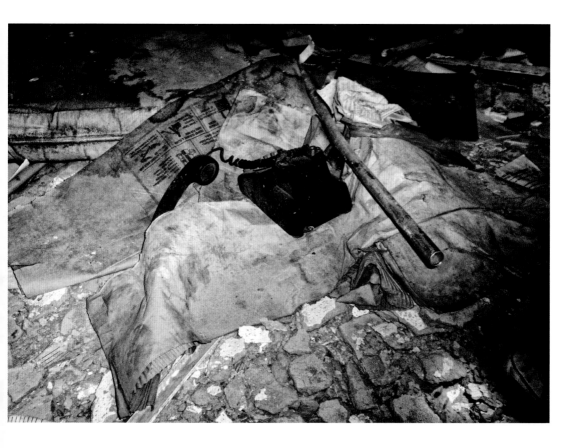

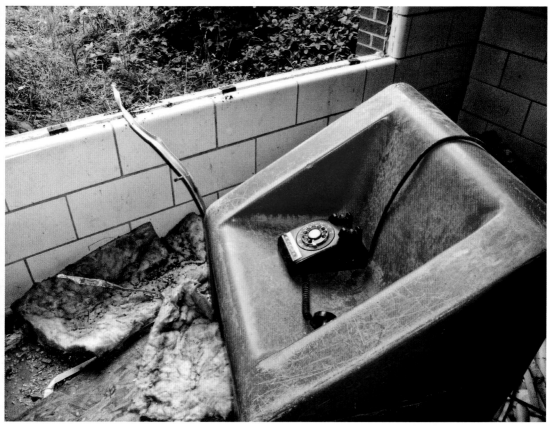

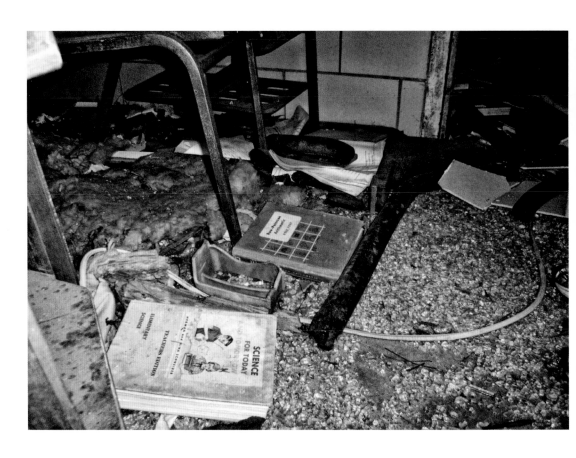

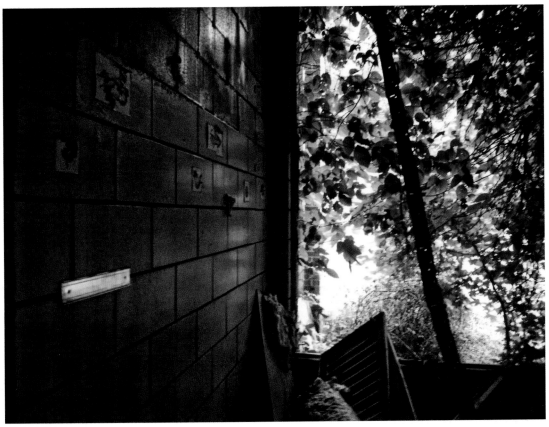

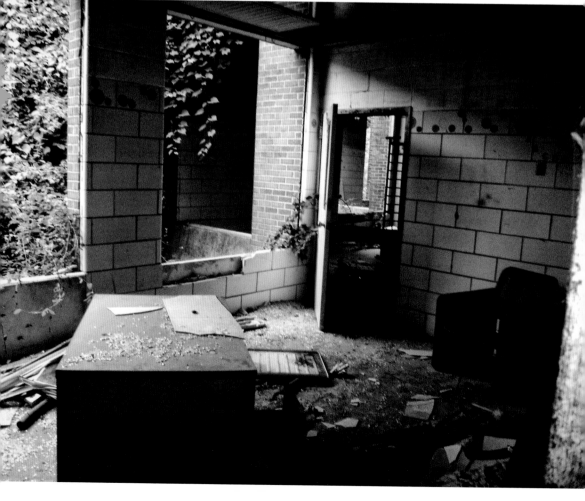

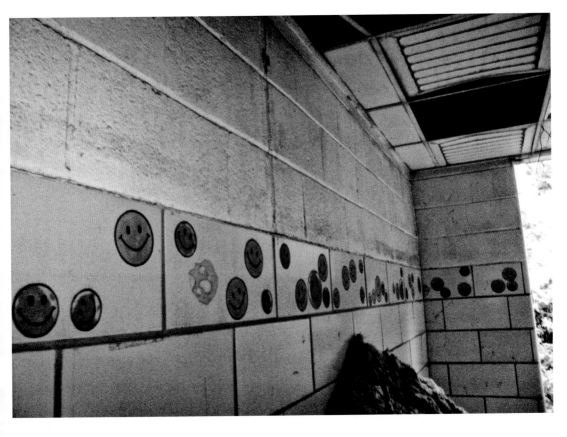

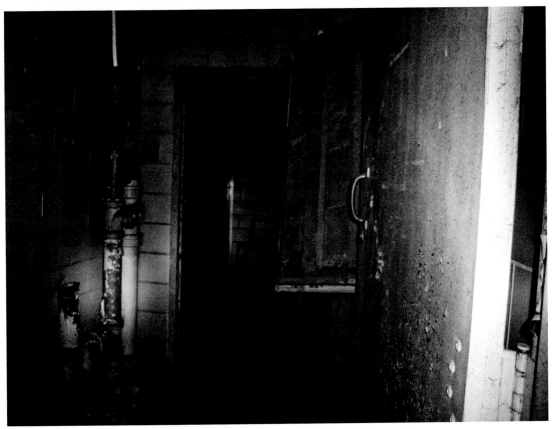

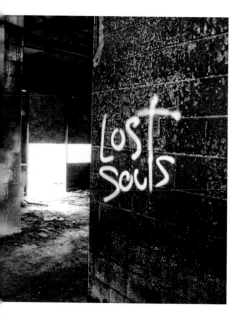
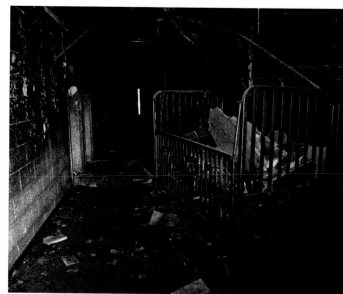
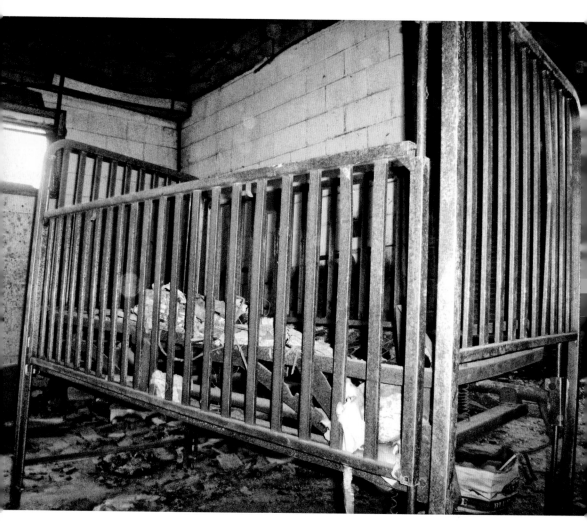

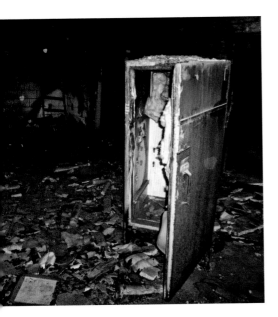

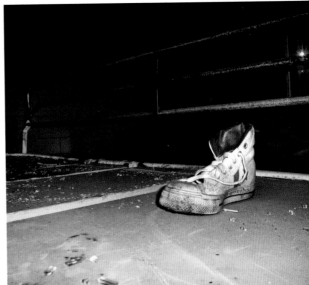

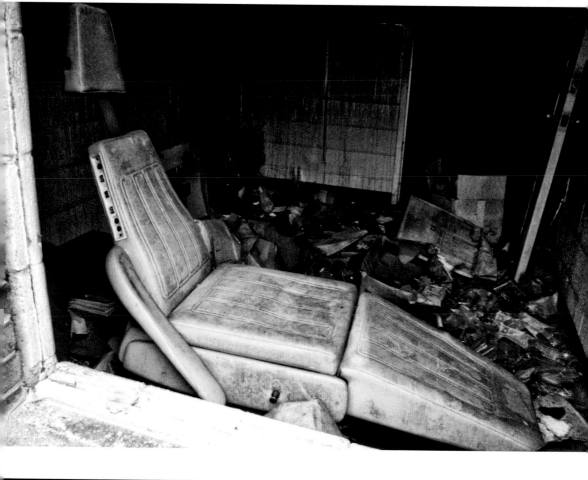

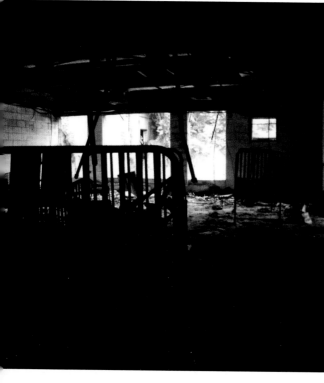

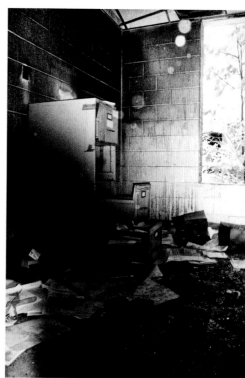

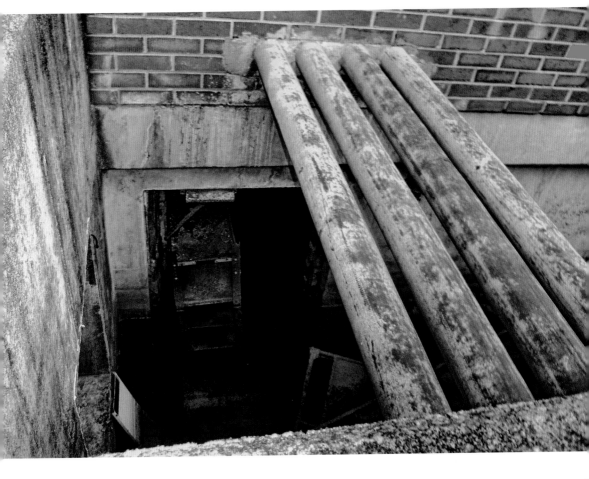

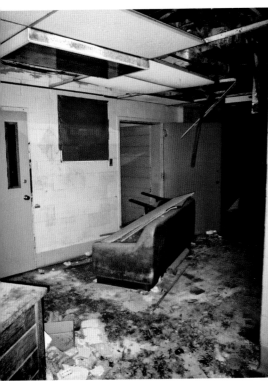

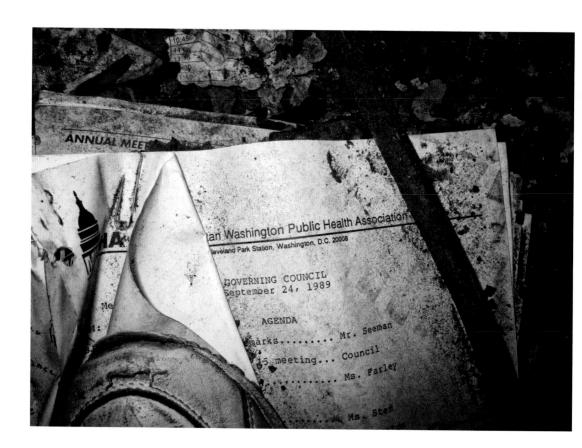

ANNUAL MEET

...ian Washington Public Health Association

...leveland Park Station, Washington, D.C. 20008

GOVERNING COUNCIL
September 24, 1989

AGENDA

...marks.......... Mr. Seeman

...5 meeting... Council

.......... Ms. Farley

.......... Ms. Stem

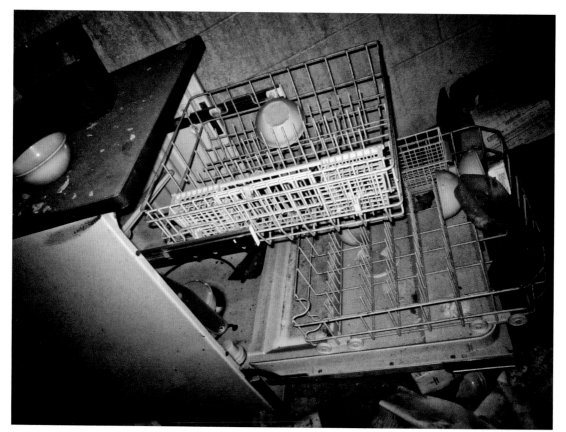

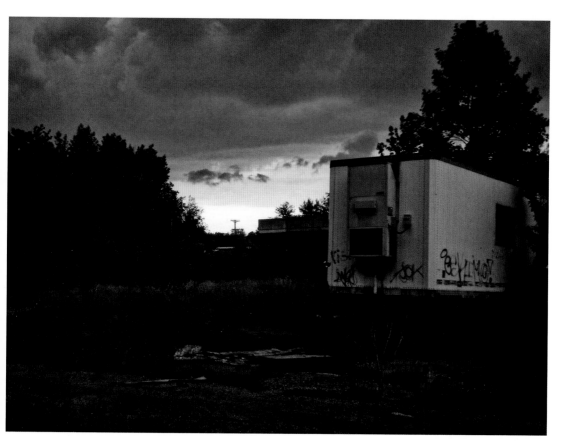

5

HOLY ROOD CEMETERY

The whole point of a cemetery is to help us remember. We erect sturdy granite markers—monuments intended to outlive us—to ensure that we don't forget, and in turn that we are not forgotten. More than most things in our disposable culture, a cemetery is built to endure. But nothing lasts forever, not even memory. At some point, memory fades, we decompose, stone crumbles—nature takes over.

The sun is setting on this hallowed ground. And when the blankness of night falls, what will be left of Holy Rood Cemetery in Glover Park except another ruin?

Holy Rood Cemetery was established by Holy Trinity Catholic Church in 1832, and it shows its age. Many monuments are worn to the point of illegibility, and many others still are cracked and tumbling. Here, the Virgin Mother is fallen, cut down at the knees, and a feeble attempt to restore her to grace belays the general indifference of her caretakers. There, a crucifix is split into pieces, a literal bifurcation reflecting the fractured nature of Christianity itself.

Toward the back, gravestones are physically propped up with wooden planks. This is likely the work of some Good Samaritan, a passerby just trying to do the right thing. These implicit good intentions stand in marked contrast to a pair of empty, shattered crypts. The precision with which certain portions of these stone containers remain intact, while other sections lay strewn about—in pieces amidst the unkempt lawn—lends their destruction the chilling appearance of deliberation; this looks like the work of a stomping boot. A burial vault hidden in the hillside near the cemetery's front stands empty, its contents removed lest a similar fate befall it.

Overgrown grass and untamed shrubs say everything about the current caretaker's approach to this neglected, tumbledown place. That current caretaker? Georgetown University, which assumed responsibility for the cemetery through some fluke of parochial restructuring back in the 1940s. The university is not interested in the resource-intensive business of cemetery maintenance. By all accounts, Georgetown would prefer either to disinter those buried here, redeveloping the land, or to simply turn it over to the modern-day parish at Holy Trinity if the diocese would accept the financial burden themselves. So far, both alternatives seem to be non-starters.

Buried here are those who fought in the Civil War, many prominent Georgetown merchants, at least one Revolutionary War veteran, and some 900 slaves, interred in unmarked graves near the northwest corner of the grounds. It's a nice Sunday, and a father and his three children play soccer there, in what appears to be a large open space adjacent to the many marked graves. Kicking the dirt playfully, they are blissfully ignorant of the burden of American sin that lies just beneath their feet. I know that in most aspects of my life, I'm an outlier—the only reason I know why that grassy corner seems so empty is because I took the time to research it before I arrived. If you wandered in casually like this family did, you'd never know that the enslaved lie there in such unceremonious repose.

But that's the way we like the shameful parts of our history, isn't it? Out of sight. Forgotten.

How long is a cemetery meant to last anyway? At what degree of remove from the present does a cemetery become an archaeological site? A tarnished and faded historical

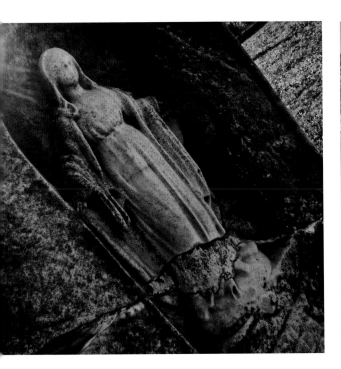

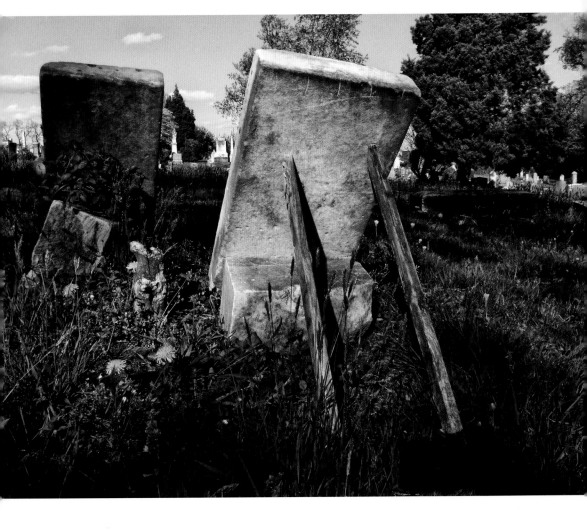

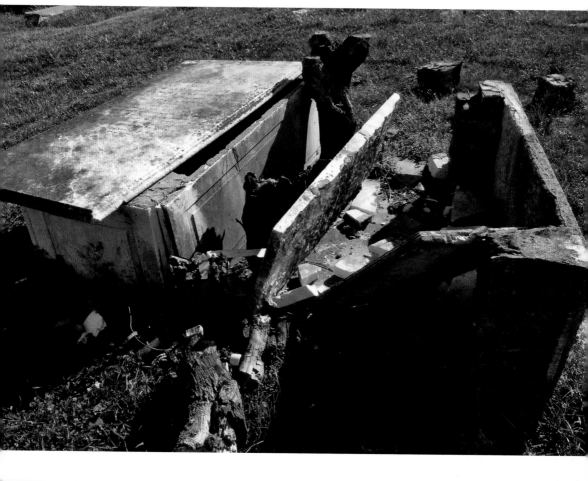

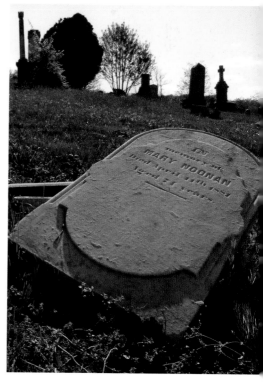

marker in some grassy park, the sacred memories of the individuals once mourned here reduced by time into mere abstractions of human beings? Racial symbolism aside, maybe that father and his kids have the right idea—the gradual reclamation of this space through amnesia. Some of the burials at Holy Rood are comparatively recent—I spotted one or two that took place in the 1970s—but the vast majority date from a century or so before that. Very few among the living have any immediate personal connection to those buried here.

Certainly, no one needs to actively destroy a cemetery, but maybe letting wind and weather have their slow way on the graves of the past is as fitting a tribute as any. There's a poetry in that which will stir you to reflect upon the world and your place in it. I defy you to be similarly moved in the well-manicured Oak Hill Cemetery down the street—but to take that dare, you'll need to bring your wallet to cover the cost of admission. The silent folks at Holy Rood won't charge you anything for their enlightened company.

> When he shall die,
> Take him and cut him out in little stars,
> And he will make the face of heaven so fine
> That all the world will be in love with night
> And pay no worship to the garish sun.

Shakespeare wrote that, and I happen to think that the sentiment is quite apt in describing the quiet, tattered dignity of Holy Rood, a place where the embers of memory persist if you can see past the smothering indifference with which they have been tended.

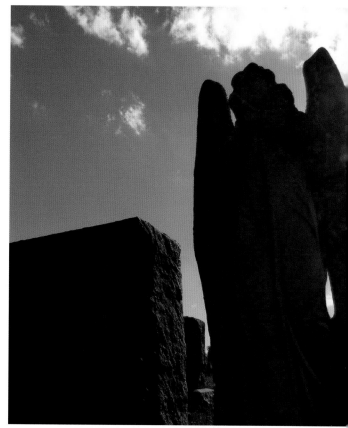

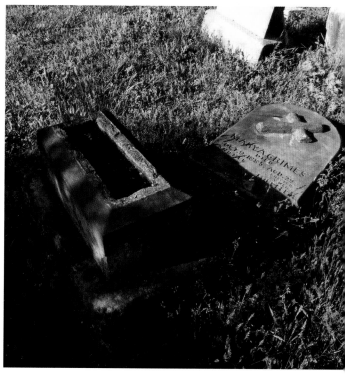

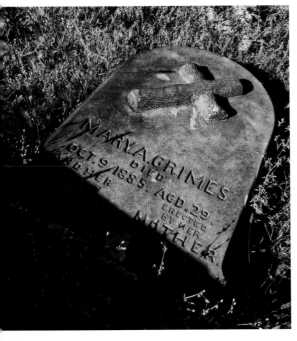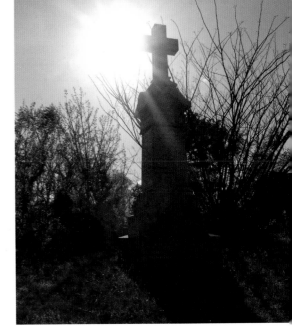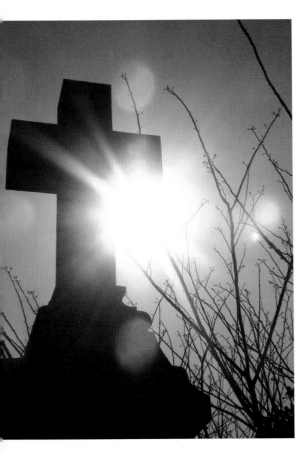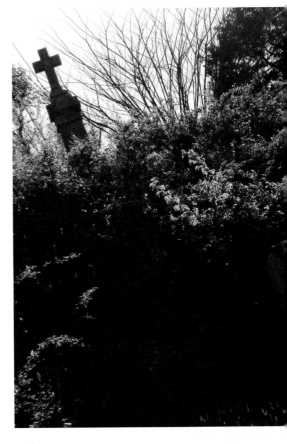

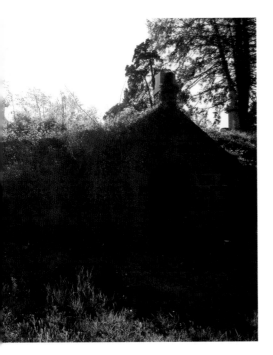

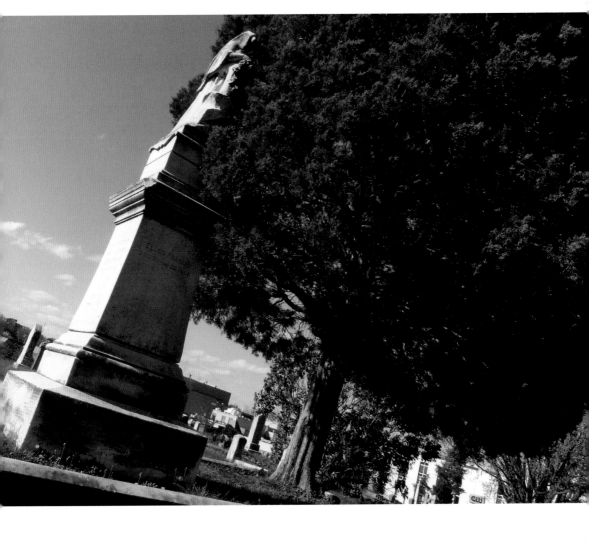

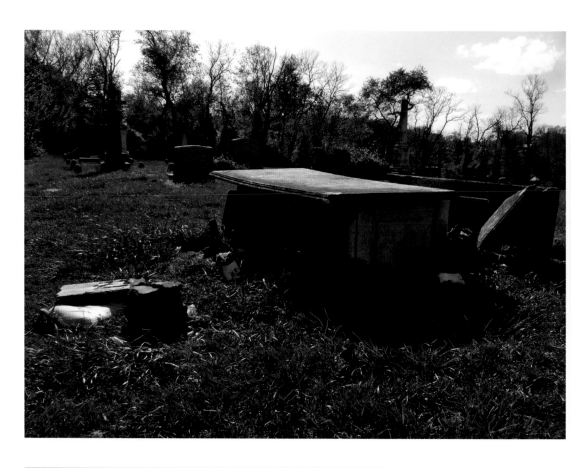

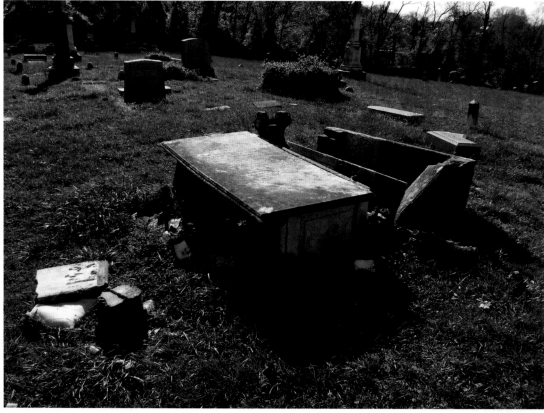

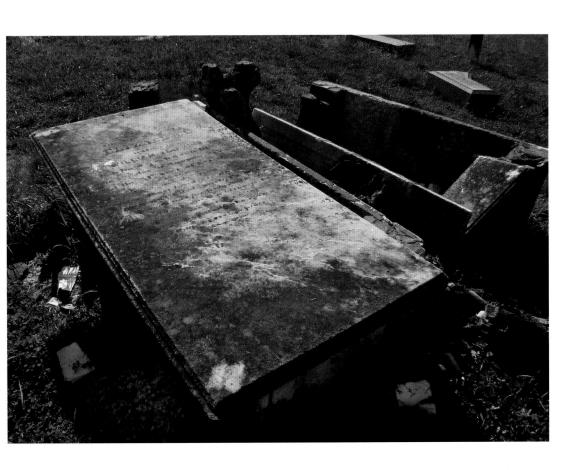

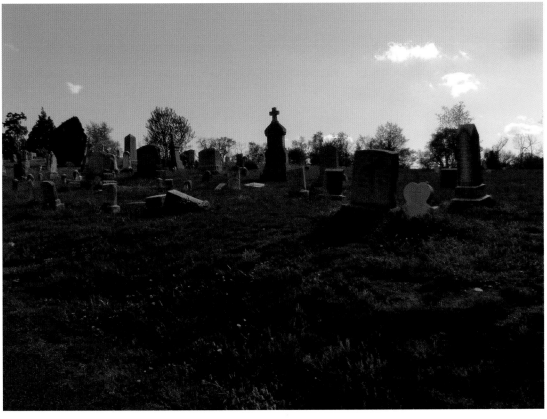

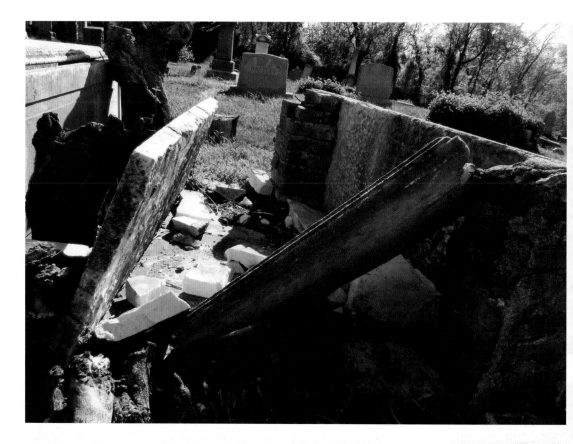

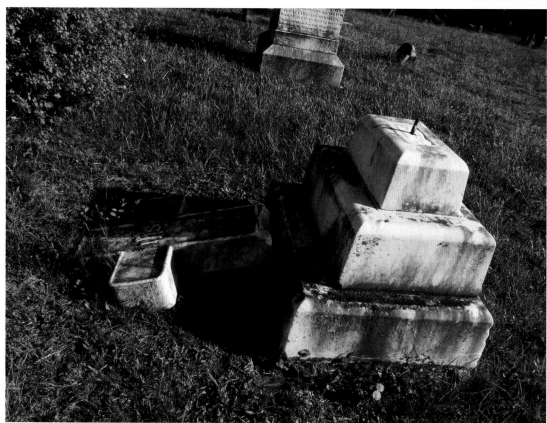

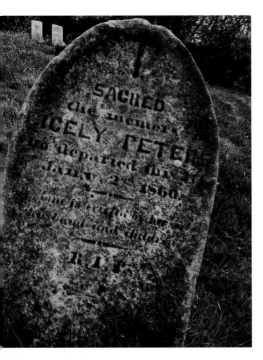
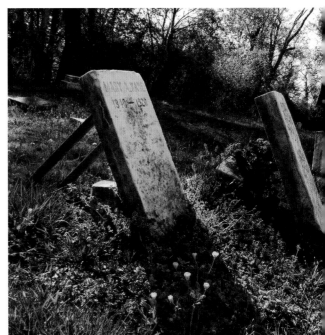
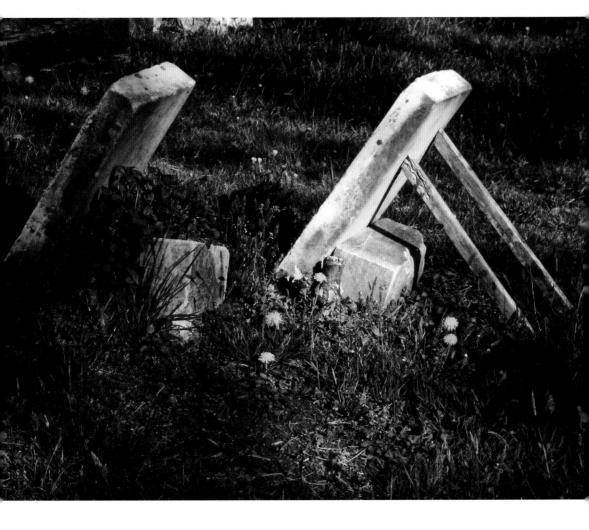

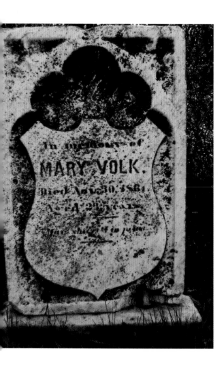

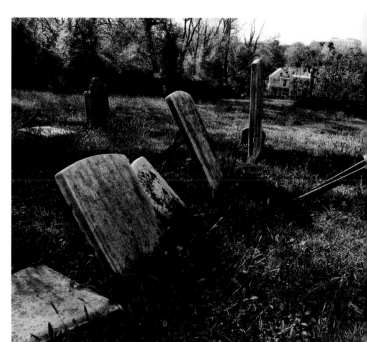

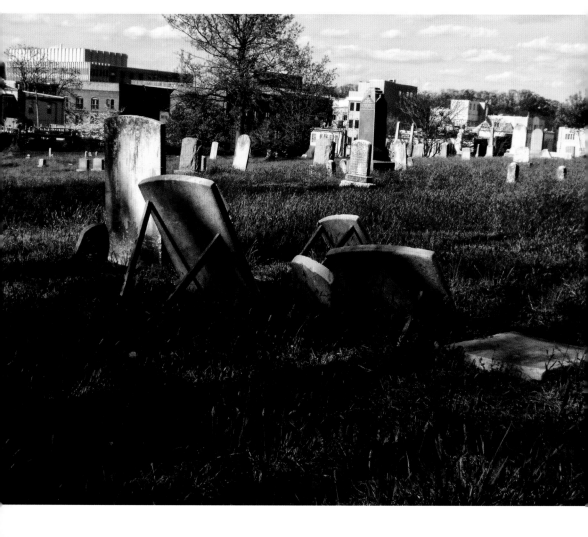

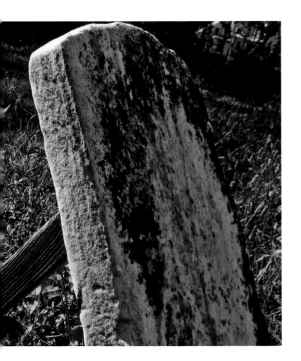
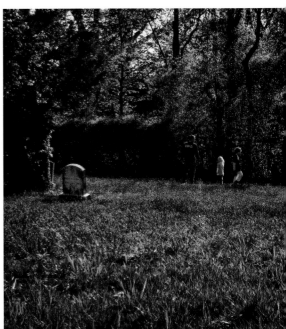
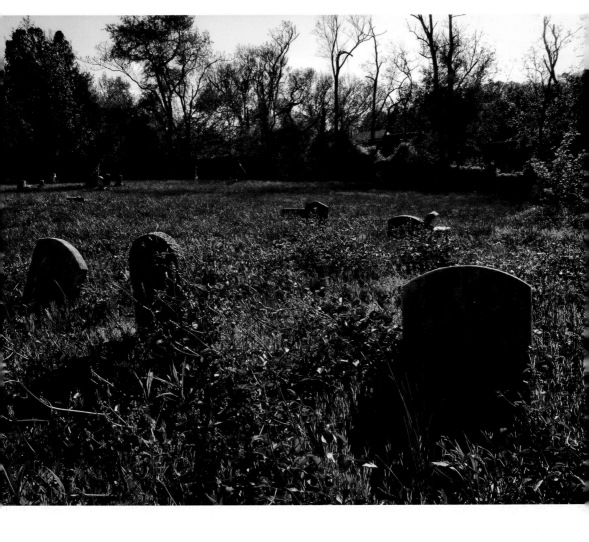

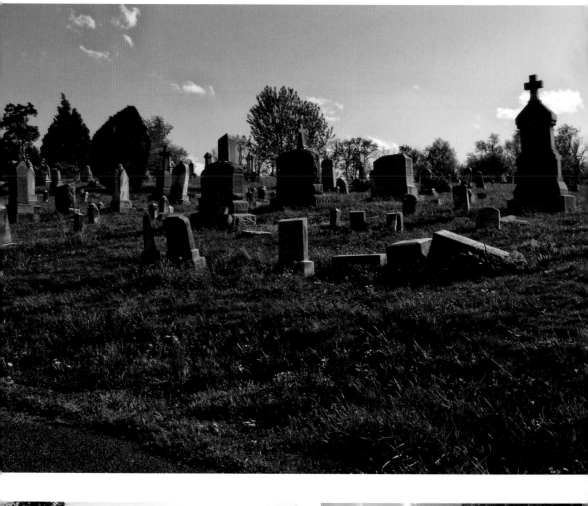

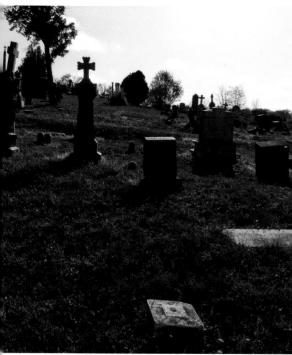

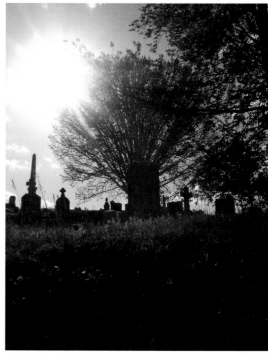

6

KLINGLE ROAD

L ook over the edge of Klingle Valley Bridge on Connecticut Avenue for an eagle's eye view of Klingle Road, or what remains of it. Twenty odd years of legal wrangling did at least as much to degrade this former arterial of Rock Creek Parkway as the 1991 storm that initially washed it out. Bureaucratic deadlock is often a boon to urban exploration—and while this former ruin is now one of the city's newest pedestrian greenways, this is really the story of humans conceding to Mother Nature's will. In our hubris, how often do we accept that maybe the ruin was better than the initial thing itself?

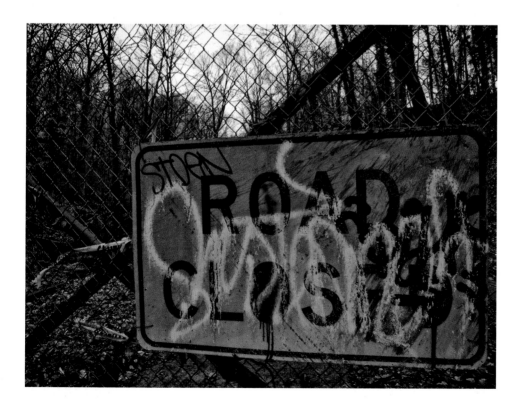

For the better part of twenty-five years, one group of DC residents wished to see the 2600 block of Klingle Road restored as a convenient east-west motorway linking Reno Road and Beach Drive. An exciting return to form—a classic venue for commuter traffic in our nation's capital!

These traditionalists were opposed by those who preferred to see Klingle Road developed along the lines of its de facto function, as a rustic pedestrian pathway through Klingle Valley into Rock Creek Park. The two factions had it out in fits and starts across two decades and any number of community meetings, case studies, and legal filings. Until this dispute was finally resolved in 2014, Klingle Road received little to no attention from municipal work crews and stood as a monument to urban neglect and indecision.

As DC's governing bodies mulled over the question of what to do with the ruins of Klingle Road, the folks who wanted one less conventional road won out by default—pavement and concrete continued to crumble as nature reclaimed what was hers to begin with. Klingle Road became a microcosm of some post-urban pastoral fantasy, and DC's drivers somehow still found their way to work.

Fallen trees crisscrossed the former motorway, breaching the surface at odd intervals with all the power of the world's slowest-motion jackhammer. New growth—seedlings and even the occasional wildflower—took hold where men no longer trod. Manhole covers literally rusted to pieces, and underground drainage pipes opened up, burping their contents onto the roadway. Successive rainfalls over the ensuing two decades resulted in jagged crags in the pavement that easily reached depths of a foot or more—watch out for your ankles, dog walkers and urban explorers alike, especially during the twilight hours. I visited on a dry day at the end of a dry week, and the roadway was still a veritable tributary of nearby Klingle Creek, which runs down the valley parallel to Klingle Road.

Near the bottom of the valley, where the roadway had indeed tumbled away completely, creek and street finally merged into one cascading channel—the way that nature clearly intended them to be.

Like urban explorers, graffiti artists revel in the inattention of authorities. Given long periods of uninterrupted time in which to work, they turned the underside of Klingle Valley Bridge into an impressive canvas. It became a colorful and discourteous pastiche of popular culture—Spider-Man, Ninja Turtles, and characters of artists' own invention, crudely rendered between elaborate tags. DC—a planned city full of well-maintained monuments and government buildings—is not known for its graffiti culture, but this was one of its hubs.

The ghost road also offered a striking vantage point on the single-arch steel Klingle Valley Bridge overhead—a section of Connecticut Avenue connecting the Woodley Park

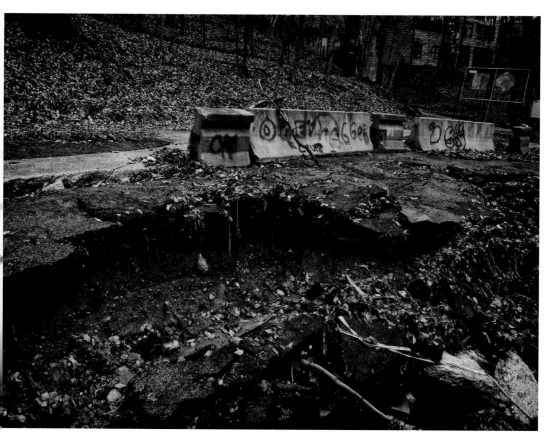

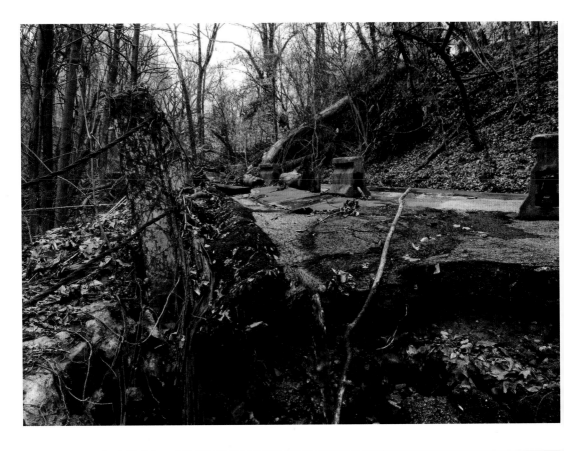

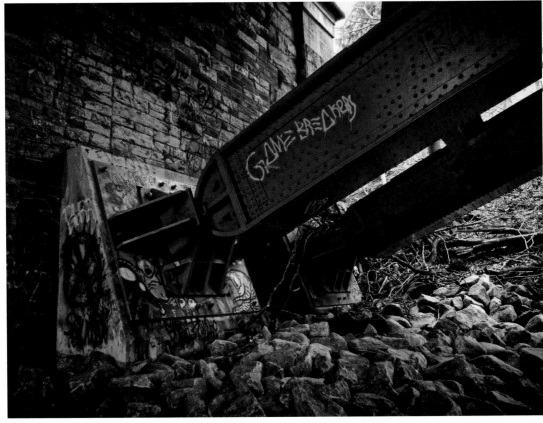

and Cleveland Park neighborhoods. This Art Deco bridge dates from 1930-1932, a trusty artifact of New Deal-era infrastructure. On the day I visited, some hapless worker left one of the usually locked doors to its internal superstructure standing wide open.

Since this was an unexpected opportunity, I was not prepared with a flashlight, but the jaundiced light of a single sodium-vapor lamp provided minimal guidance within the bridge's abutment. The heavy sounds of traffic dopplered through the tall, narrow space inside, providing a bewildering sense of movement all around. This, coupled with signs that somebody had slept here the night before and hoped to return—a shirt left to dry on a rail, an unopened can of tuna—suggested an eerie sense of life in what should by all rights be an uninhabited space.

Twenty-five years after Klingle Road first closed due to storm water damage, the cratered, eroded road has finally been replaced with a formal trail for hikers and bicyclists. A permit to begin restoration of the creek bed, retaining walls, and the installation of a new water permeable trail was granted in October 2014 and "Klingle Trail Completion" was a three million dollar line item in the FY2013-2018 District Capital Improvements budget.

Time and shifting attitudes about what we want in our cities—more greenspace, and less traffic, as it turns out—mean that Klingle Road has finally become Klingle Trail.

The pedestrians won out for once, as people decided they liked the ruin of Klingle Road better than the road itself—a little insight gleaned from the wisdom of Mother Nature's fury.

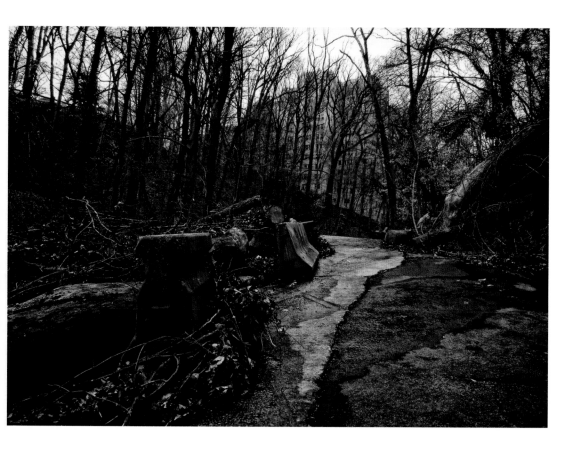

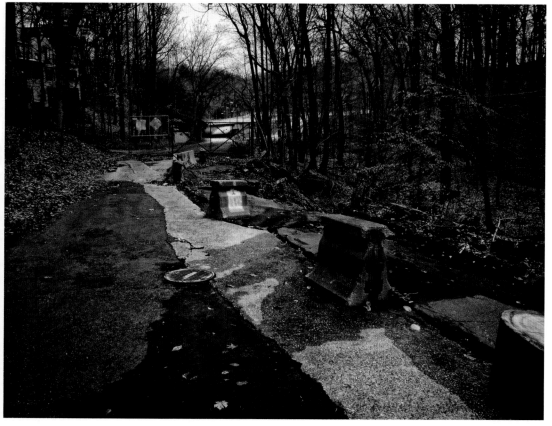

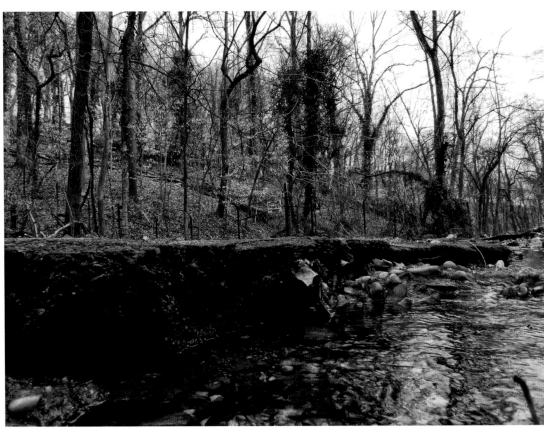

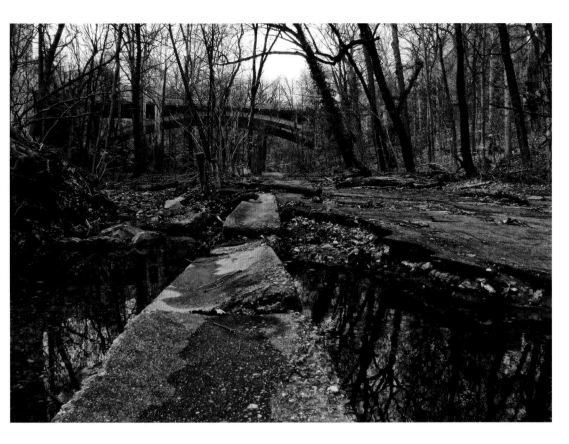

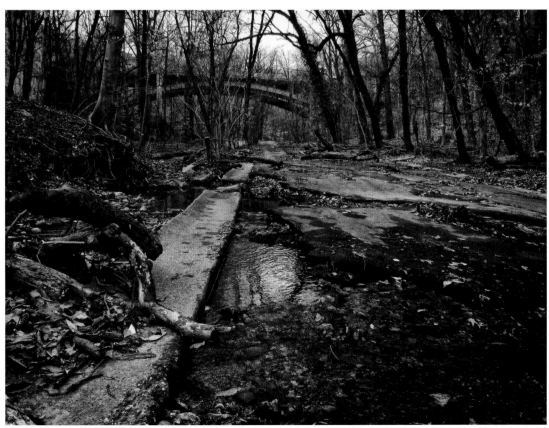

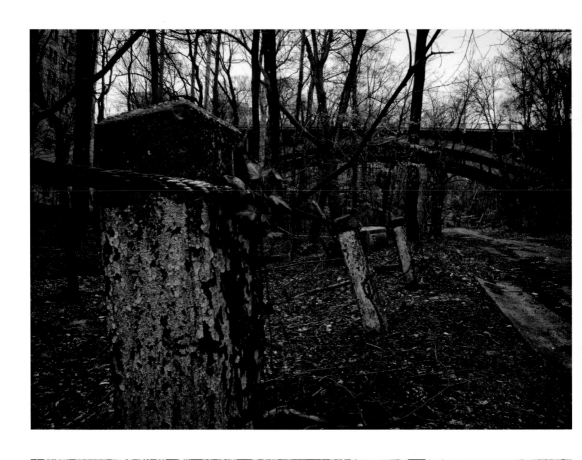

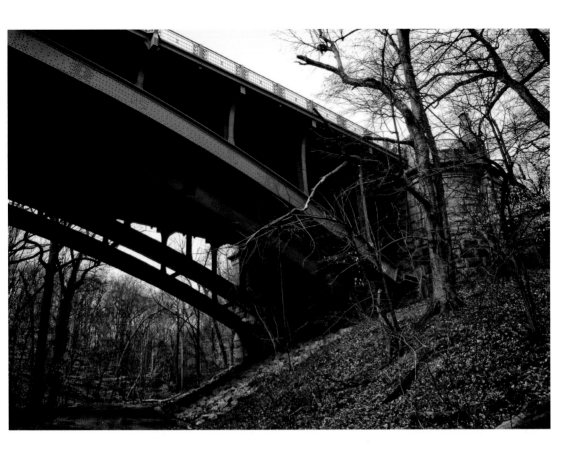

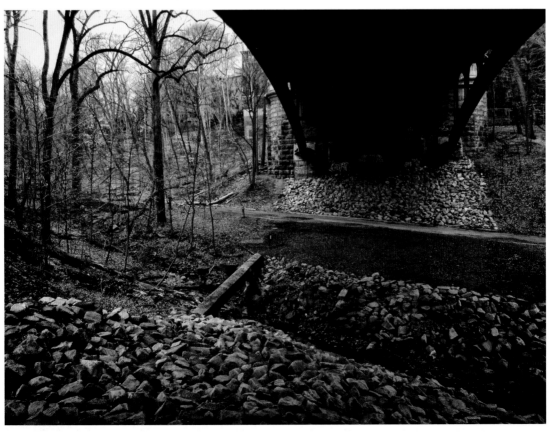

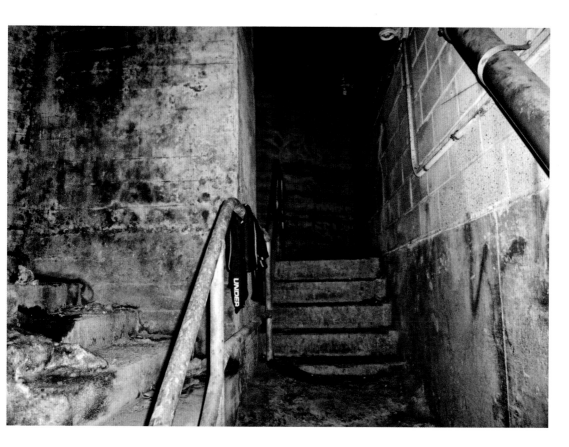

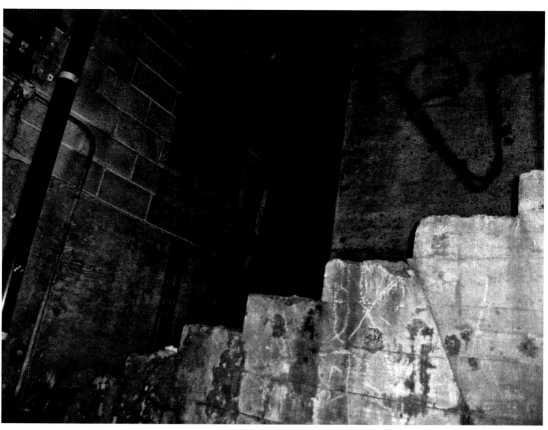

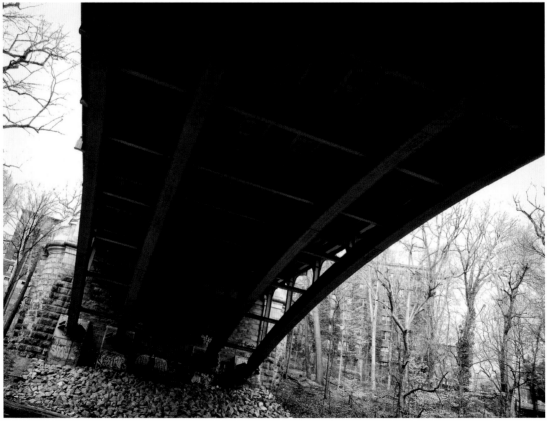

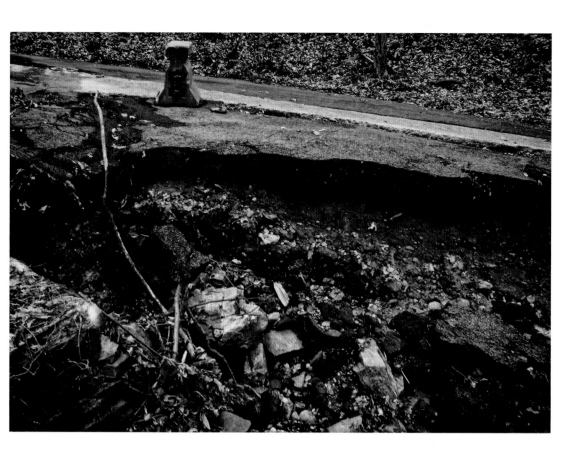

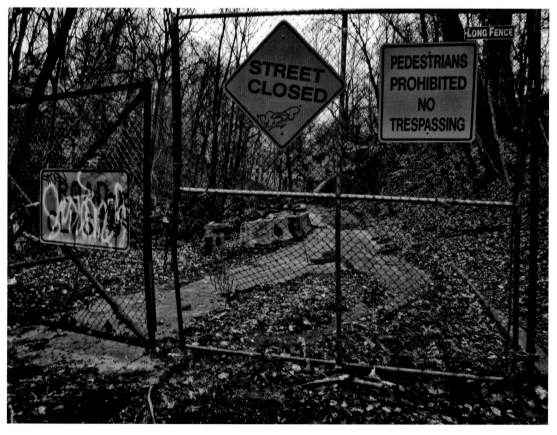

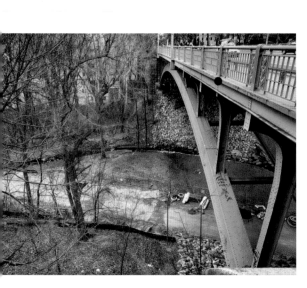
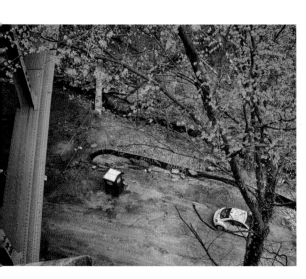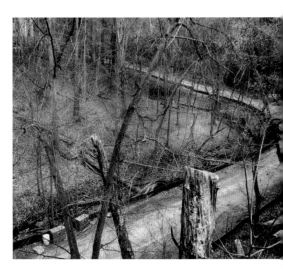

7

MCMILLAN SAND FILTRATION SITE

This was the idea: that the McMillan Sand Filtration Site in Northwest DC could be the perfect union of public utility and public space. It would meet the city's burgeoning water needs while simultaneously offering local residents an over-sized and carefully manicured backyard, a public park on the grandest of scales designed by renowned City Beautiful architect Frederick Law Olmsted, Jr. It was an idea both bold and of its time, and now, in our time, all that remains are the ruins.

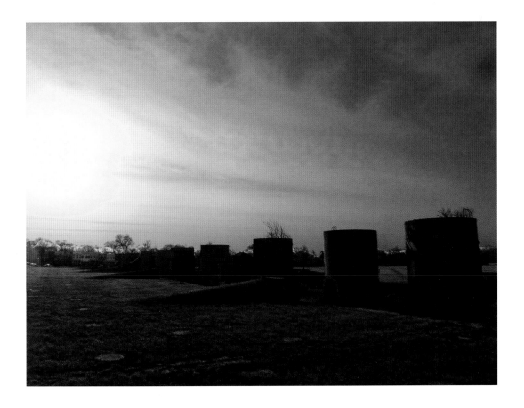

The first thing you notice about the McMillan Sand Filtration Site is the vast, open green space. In a neighborhood otherwise typified by its small, tightly packed houses, twenty-five acres of green crab grass extend from North Capitol Street to First Street Northwest. Weeds have crept in over the intervening century, and the concrete of the promenades and grand staircases have cracked, but this still feels like the kind of place you'd want to spend some time.

City Beautiful has become city vacant, keeping up with the latest fashion in post-industrial America. If you try, you can almost imagine the neighborhood kids darting in the cool spray of the towering McMillan fountain that once stood here, now dismembered and transplanted, sadly. They are chattering mirthfully in sing-song voices, improvising some elaborate variation on stickball amongst the grid of manhole covers that speckle the field like rusted red polka dots.

On those summer evenings—the kind where the air still hangs sticky and sweet for hours after the sun has set—their mothers and fathers would come down to join them, perhaps with a picnic dinner tucked under arm. In the days before air conditioning and the paranoid menace of neighbor-on-neighbor violence, the heat in their little brick row houses would have been stifling and unbearable. Half the neighborhood would sleep out here on the lawn, staking out choice spots up on the embankment. The cool night breeze would have swept over their weary heads, while the distant Washington Monument glowed in the moonlight, towering like an ivory sentinel on the horizon, standing tall and firm, belaying any ill-fortune.

This is what City Beautiful was all about—livable, breathable space that ennobles and enriches the lives of citizens. The countless happy hours spent here over the years by countless happy people would have justified the efforts of its planners, because after all, what else are parks for? All of that halcyon *joie de vivre* could have been enough all on its own.

But at McMillan Park, then and today, the main event is beneath your feet.

Multi-story concrete hoppers once held massive quantities of sand and now stand empty, covered in summer months with a prodigious web of ivy and vines. Great wooden doors, now decaying on their hinges, stand high over the cracked promenade. Some have rotted completely free, laying before gaping black cave-mouths—yawning entrances to some sublevel of the Earth. They open up on a whole other world, where Olmsted's form gives way to industrial-scale municipal function. Each arched doorway leads down a great concrete ramp into one of twenty vaulted filter cell catacombs that lie below the surface—the sand filtration system which, for several generations, supplied the District with clean drinking water.

The temperature down here is noticeably cooler, and moisture hangs heavy in the still air. My boots splash through mud puddles, the sound echoing back to me a moment later off the far wall. Though the ceiling is only about ten feet overhead, the overall scale of this chamber is truly staggering—easily comparable in volume to one of the larger Metro stations, but with all the lights out. The manhole covers that dot the lawn above—the boys' bases in their bygone ball game—were once used to replenish the sand that lines the floor of this chamber. From down here, it's easy to see which covers have gone missing over the years—a shower of light pours into the pitch dark, beckoning me to its warmth.

When they were in operation, these cathedral-like chambers would have been filled with a sluice of sand and water—tens of millions of gallons a day carried in from the Potomac by way of an aqueduct. Each filter cell was designed to hold some 3,200 cubic yards of fine, alabaster sand—that's about two hundred dump truck loads—with room for around three million gallons of water. The top layer of that sand—the evocatively named *Schmutzdecke*—served as a growth medium for protozoa, fungi, and rotifera, which feasted happily on whatever harmful waterborne bacteria was slurped into this chamber. Once they had had their fill, the water was safe to drink.

And now this engineering marvel stands vacant and disused behind a high fence, its cylindrical sand storage towers an enigma to all but longtime residents of the surrounding Bloomingdale neighborhood. Between 1905, when this slow filtration site opened, and 1986, when it was decommissioned, the vast majority of Washington's potable tap water originated here. Slow sand filtration is economical and great for the environment—it requires little maintenance and the process employs no chemicals—but it does require a lot of time and space. The McMillan Sand Filtration Site just couldn't keep up with the District's ever-growing demand for water, so the city shuttered the site in favor of a less land-intensive rapid filtration site across the street.

As for the park above, where the neighbors once slept communally and the kids played their games? That was closed to the public much earlier. After World War II, city planners became cognizant of just how vulnerable the park-purification pairing made the city's water supply. Since people could come and go in the park as they pleased, the potential for sabotage in a red scare world of secret Soviet sympathizers was just too great. The first fence went up in this post war period, and so ended an era of civic trust—or naiveté—another era that has long since passed.

In the early twenty-first century, there is talk of redevelopment. There are controversial plans to pave the green space and seal off the disused filter cells below in favor of extensive housing and shopping developments above. The city used to allow biannual tours

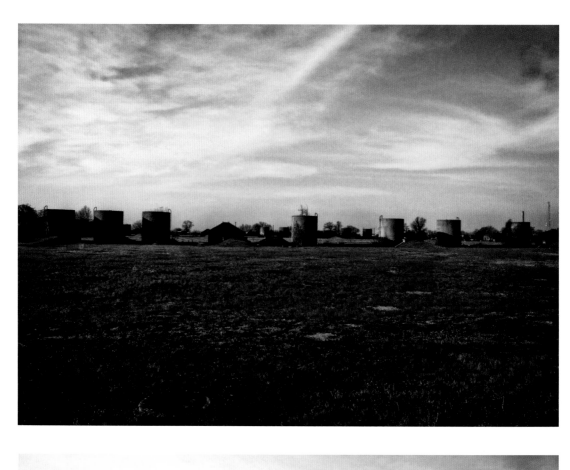

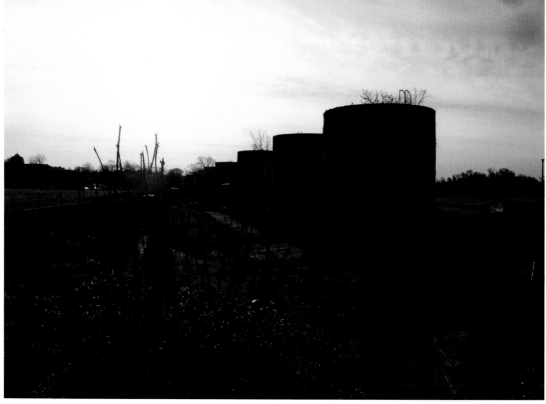

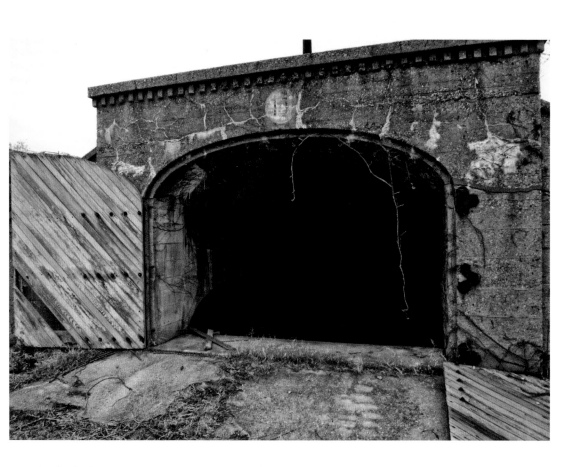

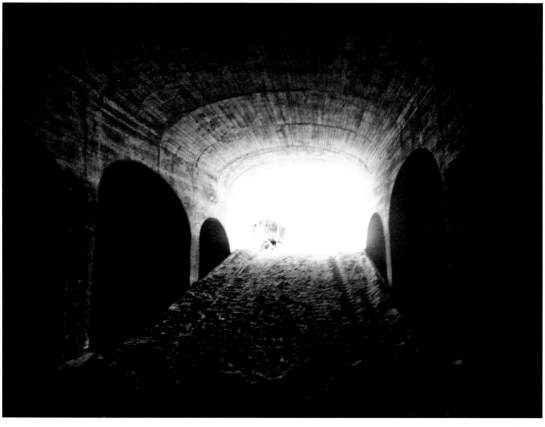

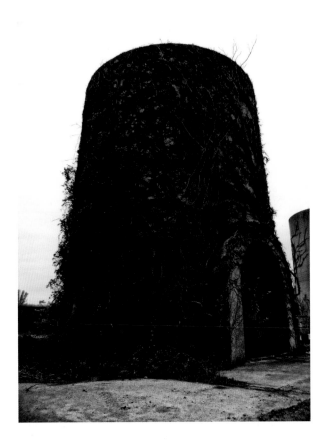

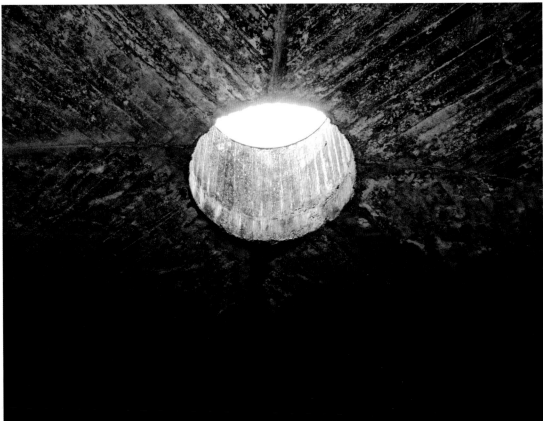

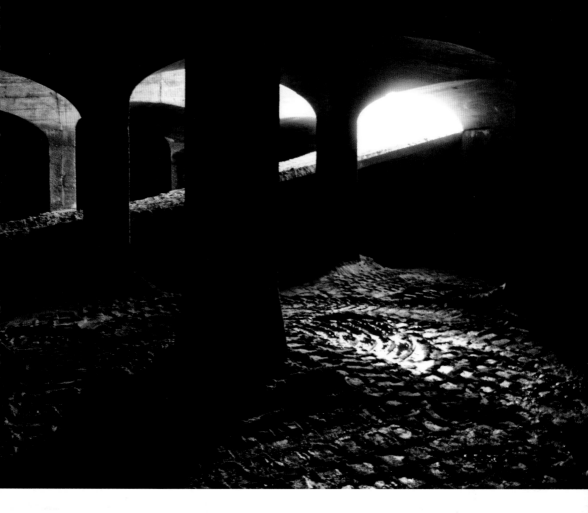

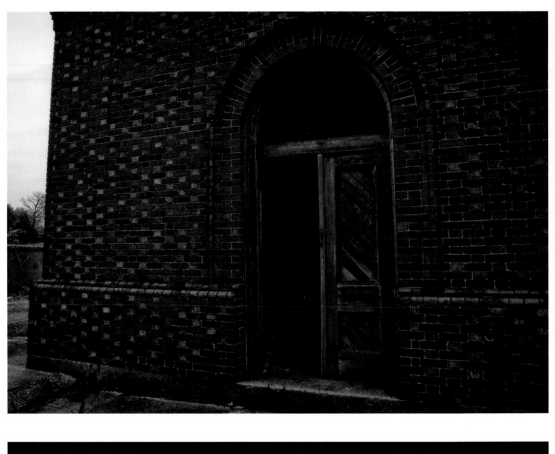

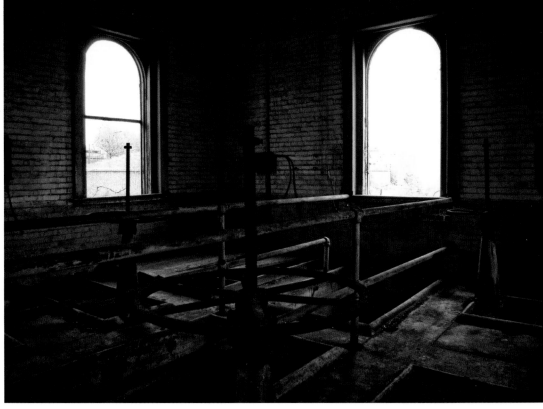

of the site, opening the heavy wooden doors to any members of the public who wished to visit. Recently, access to McMillan Sand Filtration Site has been further restricted as plans for redevelopment have accelerated. Two of the cells have been excavated for use in emergency storm water retention, an effort to curb hazardous runoff from the still operational rapid filtration site nearby.

But as we peer through the chain link fence, looking upon the McMillan Sand Filtration Site in its hobbled, faded glory, in what are very likely its final days, let's not forget that first, original germ of an idea: that a single space can serve the public good on multiple levels all at once, all without an anchor store or subterranean parking garage in sight. The McMillan Sand Filtration Site stands as a triumph of municipal design—a triumph whose time has seemingly passed. But perhaps more optimistically, we can hope that it is a triumph whose time will come again. If ideas have an afterlife, maybe the elegant integration of form and function embodied here still has a chance in some future, more urbanist America.

Those manholes punctuate the mottled grass like some great ellipsis on one of the District's finest open-ended thoughts …

Catch your last glimpse of this distinctive part of DC history before it disappears forever.

In 2016, an extensive redevelopment plan was finally approved by the zoning commission.

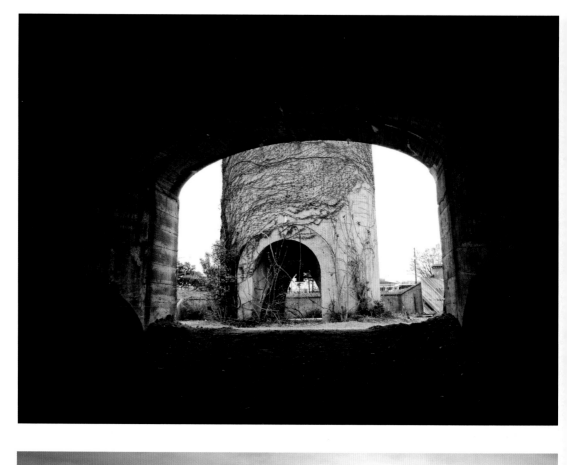

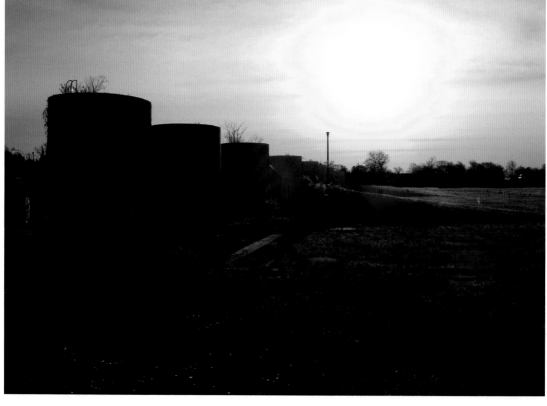

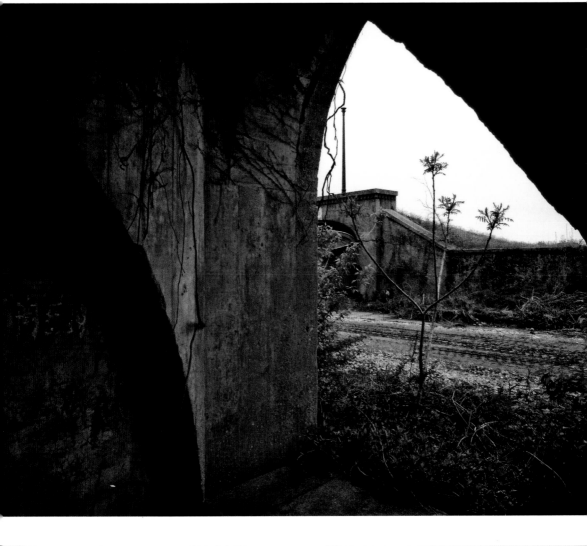

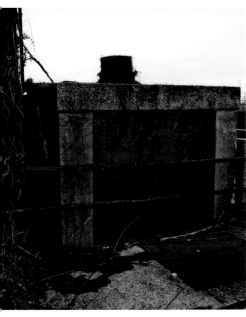

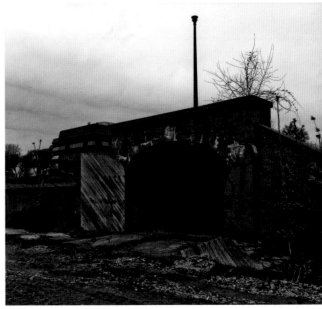

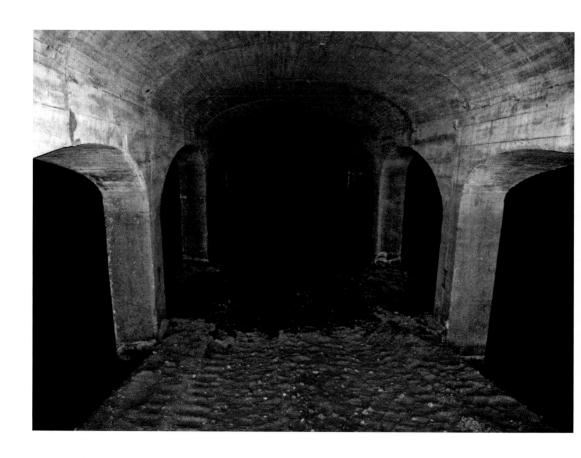

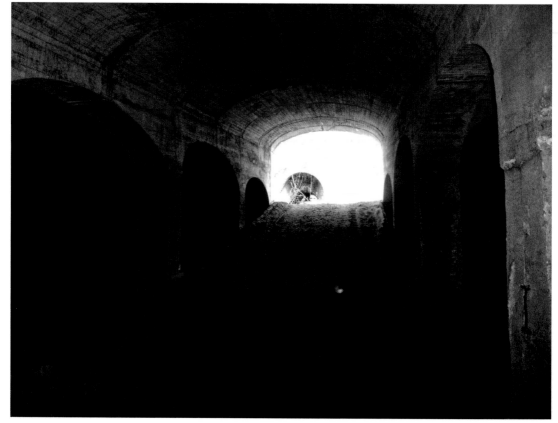

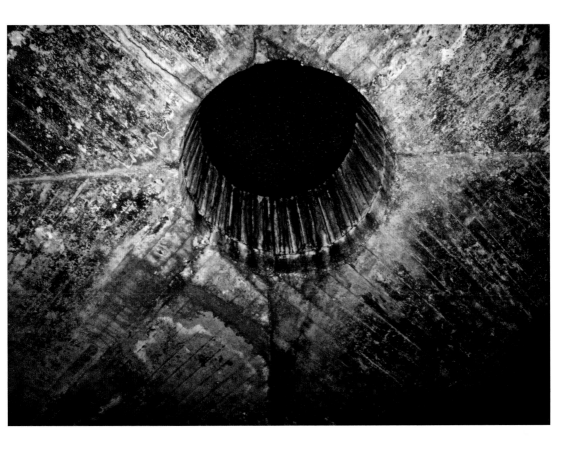

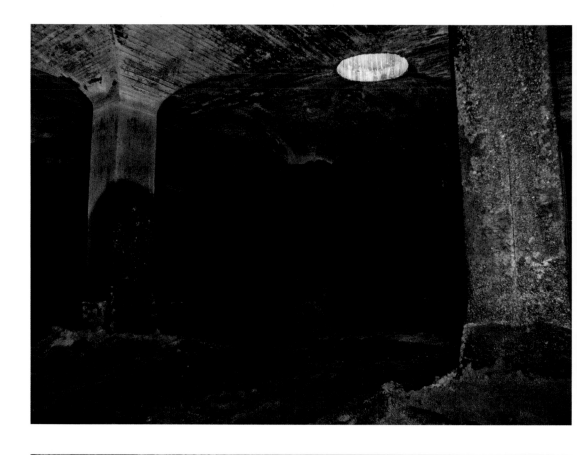

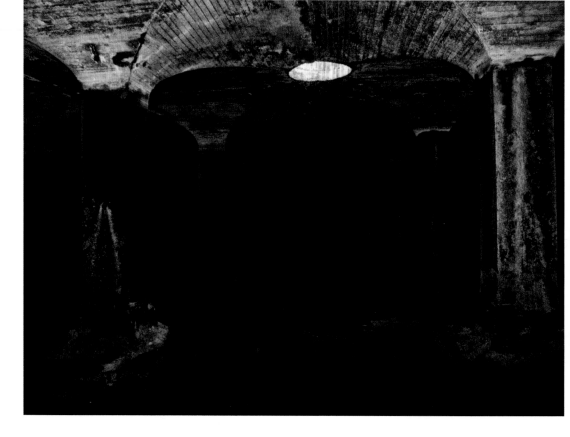

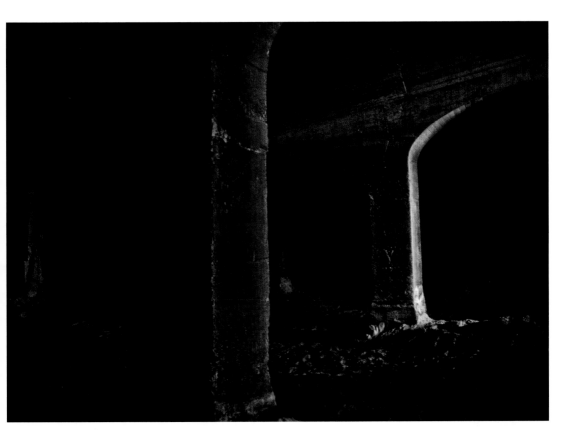

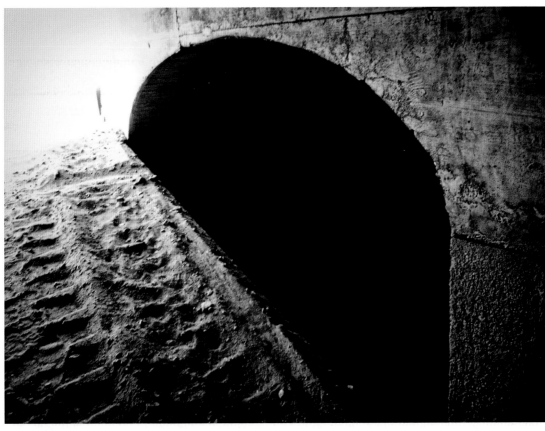

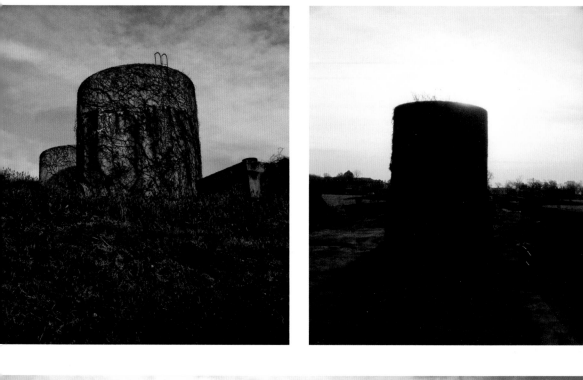

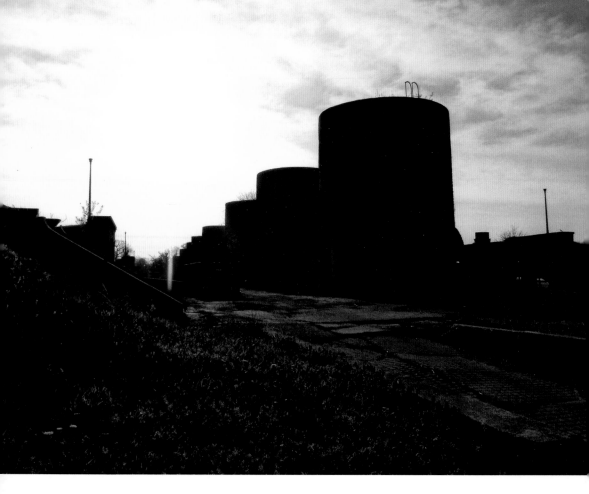

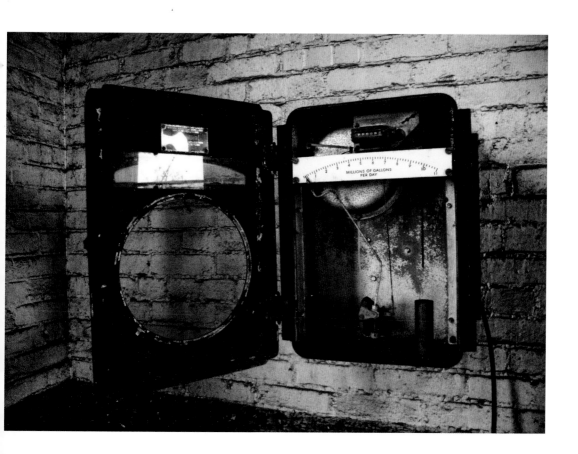

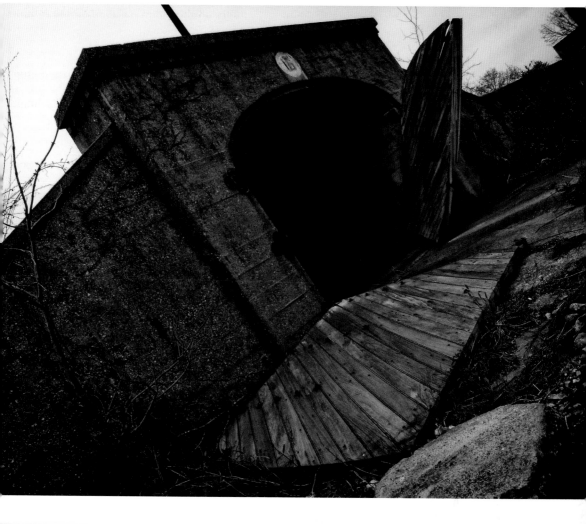

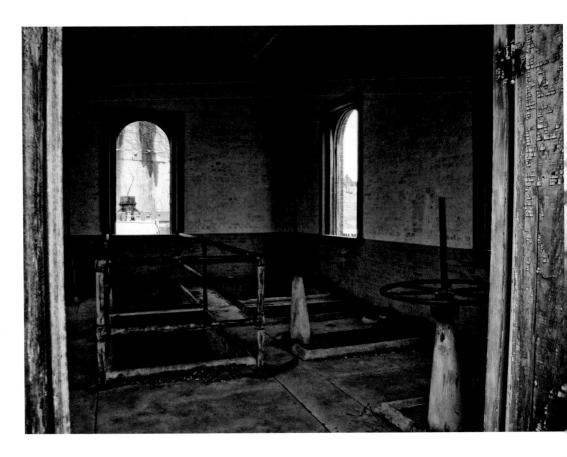

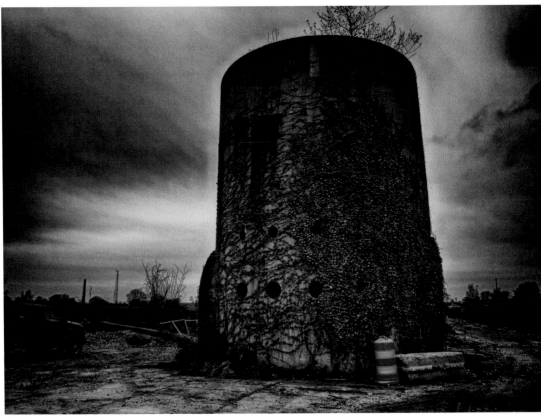

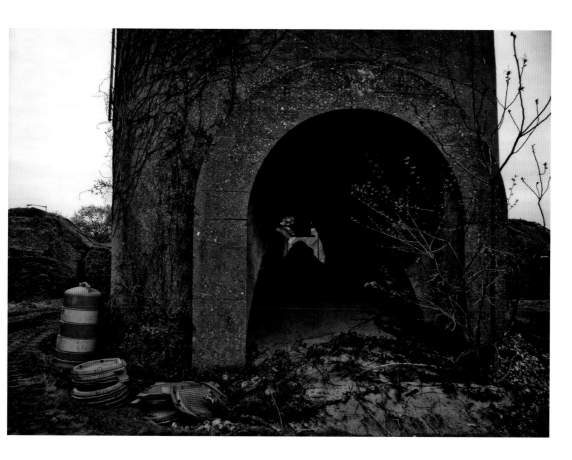

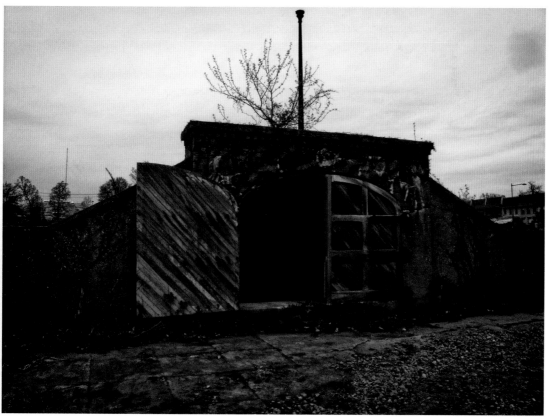

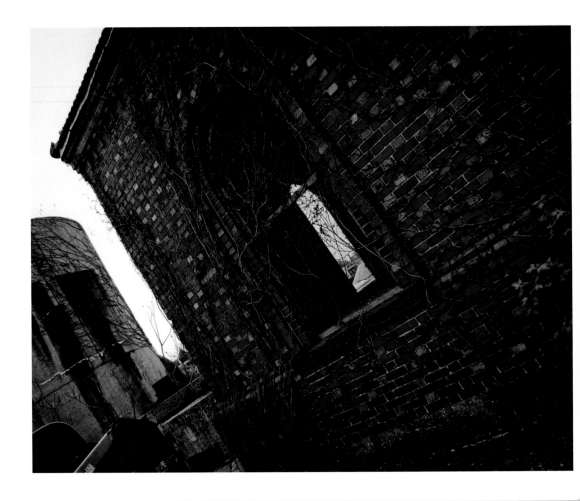

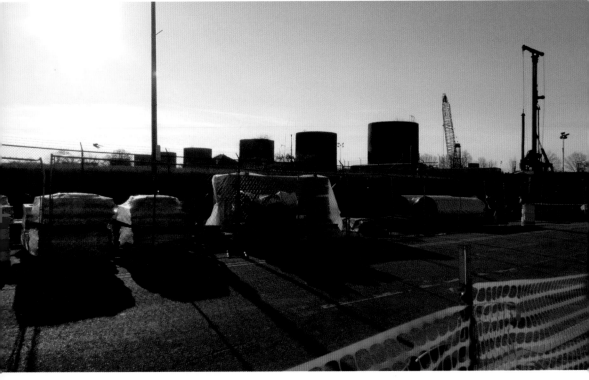

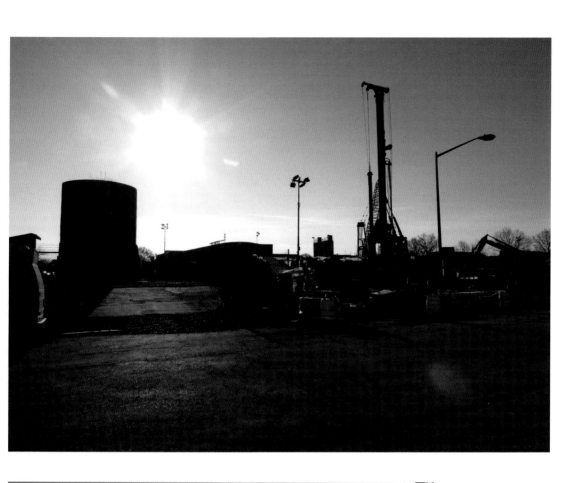

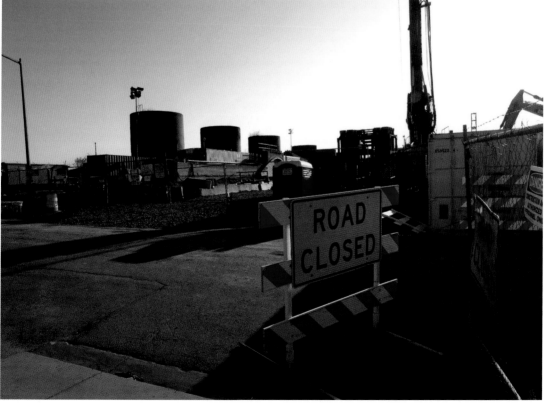

8

NEW YORK AVENUE

There are about five blocks of New York Avenue Northeast that we all know, even if we've never really stopped to look. You whisk past it on the Megabus to Philly or on your way to a breezy Saturday in Annapolis. Most of the storefronts are closed, most of the buildings are vacant. And the cops have better things to worry about than your speed.

It is filthy and crumbling, its foundations cracked on the faulty promise of equal opportunity. The idle, vacant factories, the abandoned homes, the burnt-out, broken-in storefronts … it's so gritty and real. It's another world, and I'm a born adventurer. It should be a playground for urban exploration. But I can't bring myself to enter many of these shells.

Oh, it would be easy—the boards have already been plied away, the windows broken out, the locks forced—but I am scared witless to go in. An unknown someone has already been here. It was no historical Lincoln or long gone nineteenth-century seminary student. Even the brave developers of the self-styled, Metro-branded "NoMa" (est. 2004) haven't ventured this far up New York Avenue. Yet.

Maybe television has taught me hysterics and paranoia, instilled in me a falsely inflated fear of neighborhoods like these. But even the local police precinct has a twelve-foot razor wire fence around it. And thirty-six hours after my visit, a drive-by across from the "safe," gentrified Metro stop wounded thirteen.

The people who have blazed trails into these bombed-out structures weren't here to play or make money. They were here because this is where they've found themselves. Looking for a quiet, relatively safe place to rest, shelter from the rain, reprieve from predators, be they in uniforms or in imaginations they can't quite control. The people who found their way inside these buildings were almost certainly victims and survivors of one kind or another—the marginal looking for cover from the next raid. They were the poorest, the most disturbed, the most disadvantaged inhabitants of the most blighted neighborhoods in our city.

If I followed them into that boarded up building, with no windows or light inside, I'd be facing them alone.

And frankly, aside from any fear for my own safety, I just don't know what I'd say.

I might stammer a feeble, "I'm sorry to disturb your rest. I'm sorry to intrude. I'm just here to play. For me all this squalor and decay is fun. This is your home. This is my playground. It's a hobby for me—a chance to escape my everyday life, where the walls are always painted and the windows are usually clean. I'm a tourist here, and these photos will soon be online, on the website I curate, in a book I'm working on. You should really check it out."

That's the dilemma that keeps me from writing about certain other ruined DC sites, and for a while I thought that it had stolen my tongue on the subject urban exploration. But now I'm pretty sure that what looked like a roadblock is actually a detour to a new, more challenging place—exploring the privilege implied by seeing beauty in decay.

On my jog up New York Avenue, I encounter the movable but unmoved ruins of a society in disrepair. The crumpled evidence of a fender bender covers cracked concrete. I nearly trip over a discarded floral print canvas purse, rifled through by the eager hands of an indefensible man. Its remaining contents—some make-up, an unused condom, a fast food coupon, telling the fractured tale of some young woman's bad luck—are strewn in the spotted winter grass, devoid of any items that could be spent or resold.

I see the shells of commerce, warehouses and storefronts standing like tombstones over blue collar America, an America where people did their business face-to-face instead of online. They stand as memorials over jobs that aren't coming back, over middle-aged men who know only one trade, and over families struggling to make ends meet. The tasteless epitaphs splayed across their edifices read "Prime Location for Lease." In truth, the neighborhood's best hope for revitalization probably lies in complete demolition. NoMa: Phase Two. NoNewYo.

That has absolutely no ring to it at all. And if it came to pass, would it help the current residents of this neighborhood, or simply displace them to some new urban periphery?

Urban exploration throws light upon the darker side of capitalism—the dimension of economic and social disparity that lets me have fun in someone else's part of town and then go back to my cleaner, safer side before the sun goes down. It's a dramatic enactment of the economic and social forces that govern our very divided communities. Those forces allow me to go back to my high-speed internet connection in order to upload these photos as a trophy of my brave foray to the wrong side of the Amtrak.

For me, part of the thrill of urban exploration comes from visiting another world—one that's crumbling, one that's prime has, arguably, passed. There is a degree of cultural imperialism here, through which I appropriate the toughness of another neighborhood to sharpen the blunted edges of my own. In fact, I began to explore DC's abandoned places when I began graduate school and I could no longer afford to travel abroad. Urban exploration offered all the thrill of the third world, but right here in my own town. Each visit is transgressive, and therefore thrilling—society has taught me to value the clean and the new, and growing up in the suburbs during the 90s, that's mostly what I've had the fortune to experience.

We all have free will, sure, but so much of life still boils down to the accident of where you are born. Our system perpetuates itself. To what degree we are passengers or agents of change within that system, I don't know … But not everyone on New York Avenue is just visiting.

Should I feel guilty about my interest in urban exploration just because I grew up with relative economic privilege? Because I now have a middle-class job and home of my own? Would I even be so interested in decay if I lived in it every day?

This gives me pause. As I stand on this curb, I can feel a steady wind at my back. Bright and shimmering, newly-leased cars race the red light behind me, teasing the traffic cameras at the intersection of New York and Montana Avenues. Air rushes into their wake, eager to fill the pockets of low pressure left by the violence of their passage.

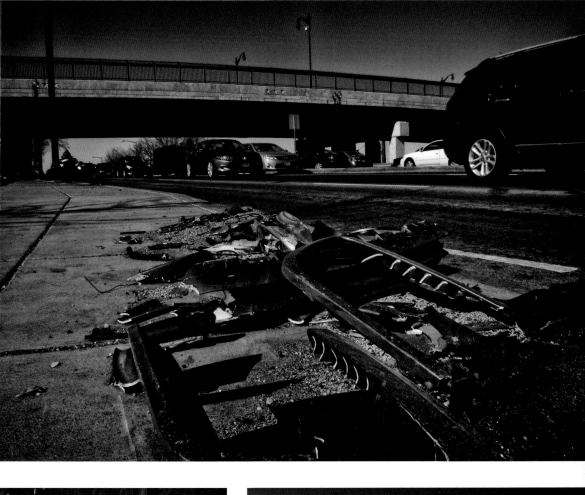

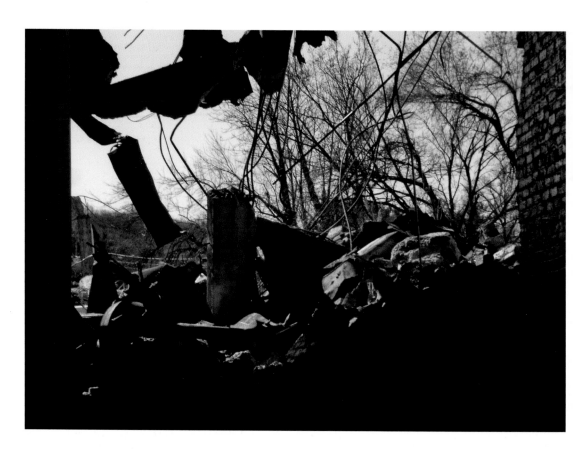

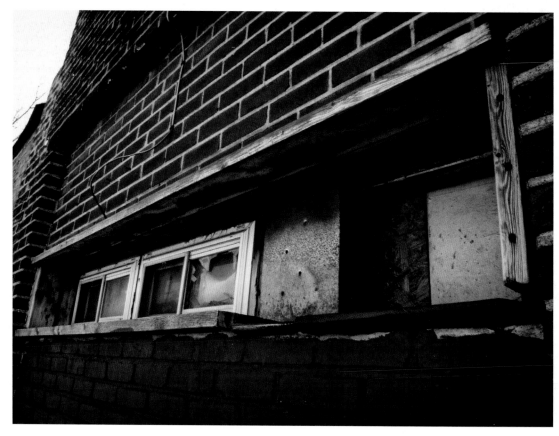

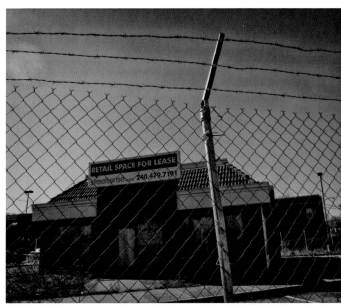
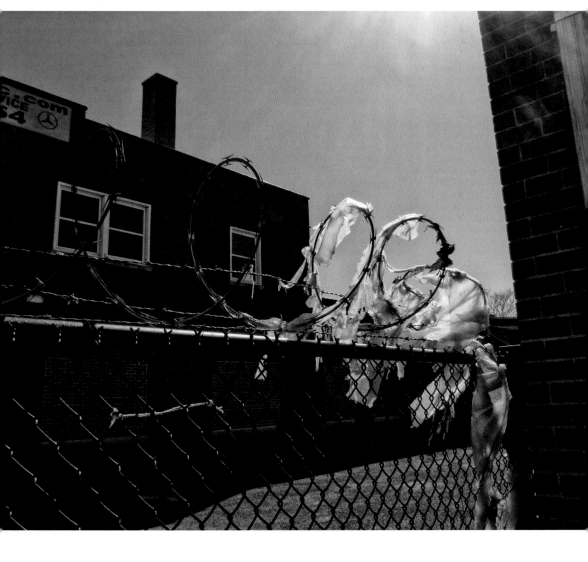

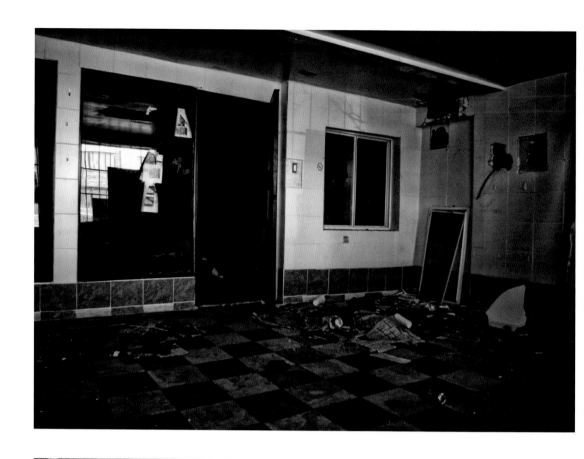

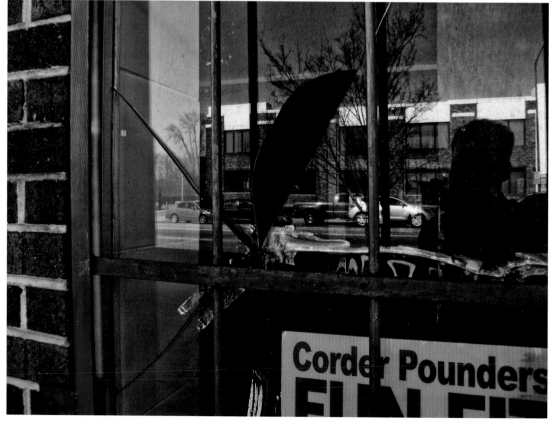

It's a beautiful Saturday morning, and I'm standing out here undertaking a moral exploration alongside my urban one, asking myself, "Should I or shouldn't I go into these shambles?" You probably think this is much too heavy.

I just came out here for the thrill. To poke around. I just came out here for some fun, but …

There is value in meditating on the social forces that make one man's ruins another man's home.

The American dream is bigger, faster, newer, and shinier each year. Yet there are those among us—the homeless, the ill, the indigent—who live a life wholly at odds with each one of those ideals. There are also those of us who have the power, privilege, and means to access those ideals—we, the beneficiaries of capitalism, who are taught by commercials and by our parents to dream of something better and nicer. Because we deserve it.

Some of us are still drawn to the squalor. It is a tacit, dawning acknowledgement of our national mortality, one that collectively we are not yet ready to articulate. We worship Silicon Valley. Yet we sneak peaks at a vacant and demolished New York Avenue. Urban exploration—on some level—is the pornography of destruction. It is a snuff film for the American dream.

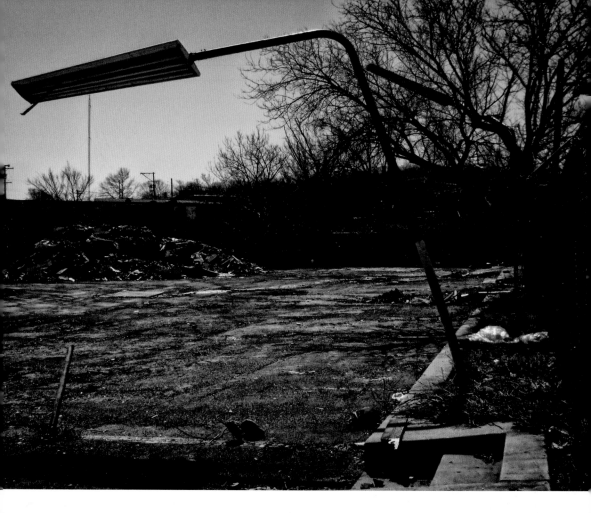

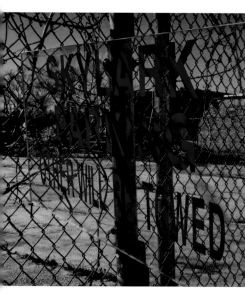

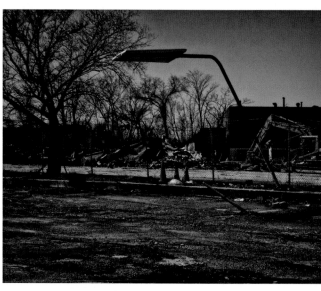

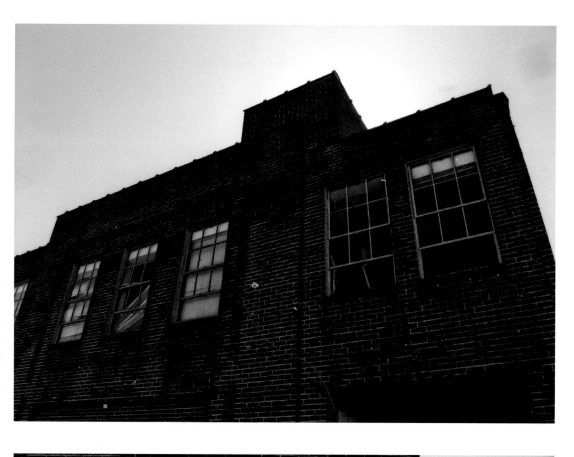

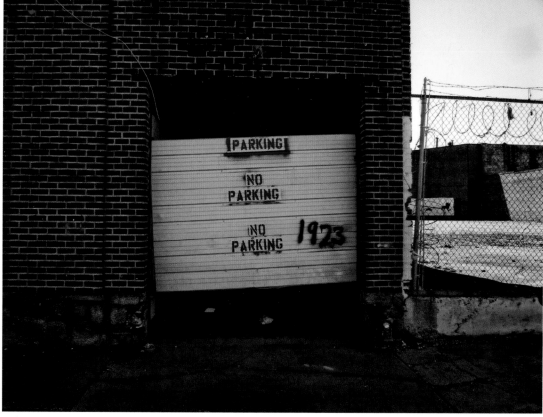

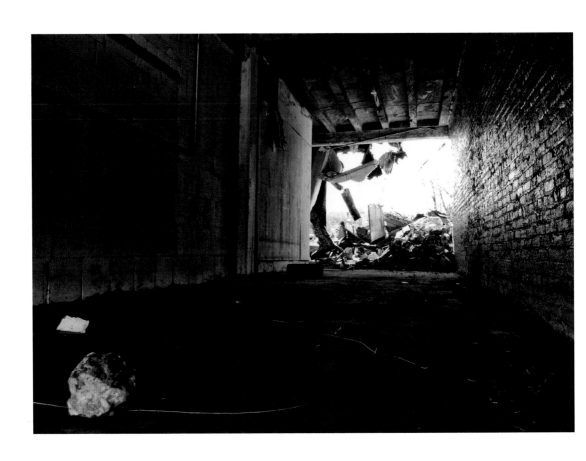

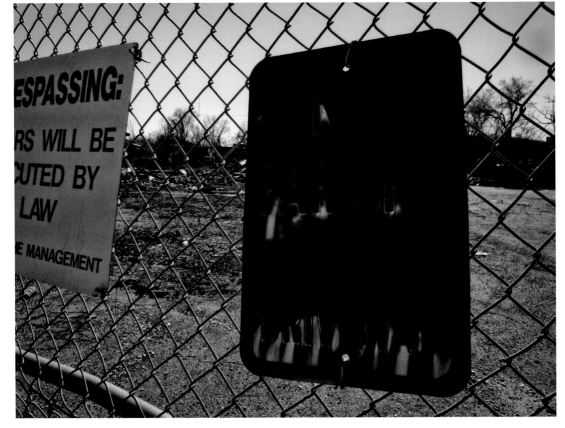

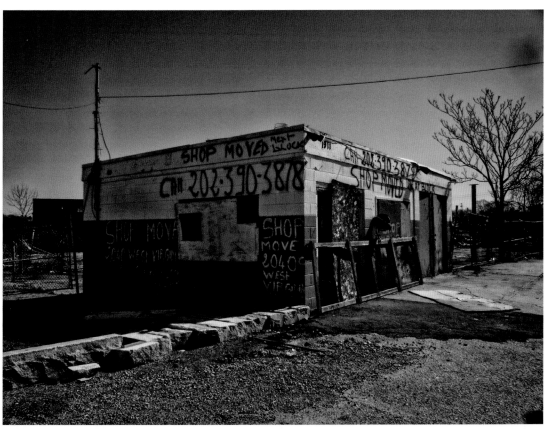

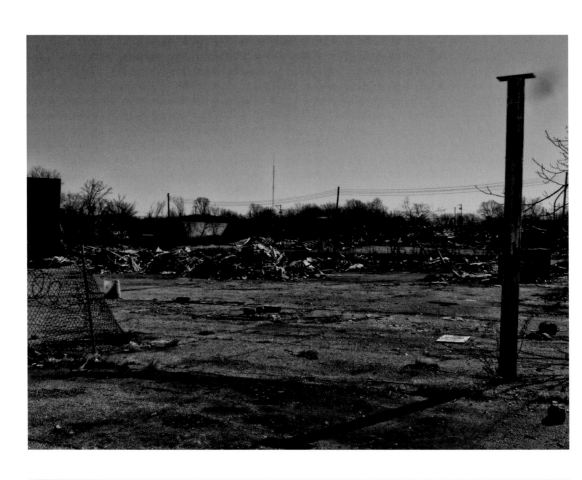

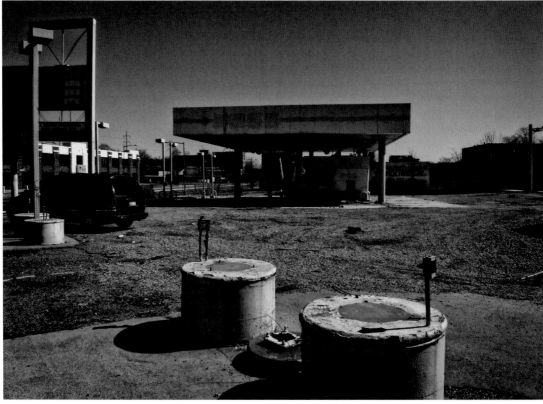

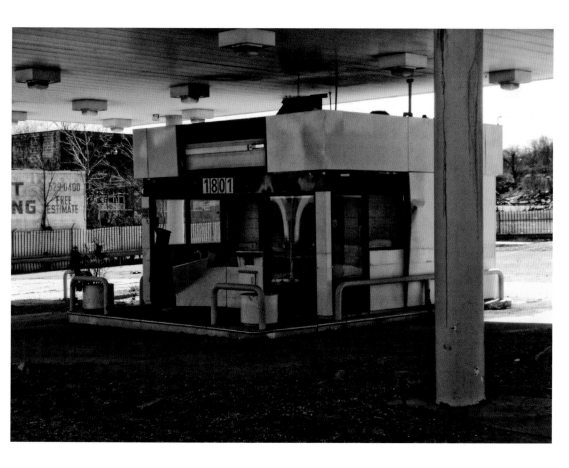

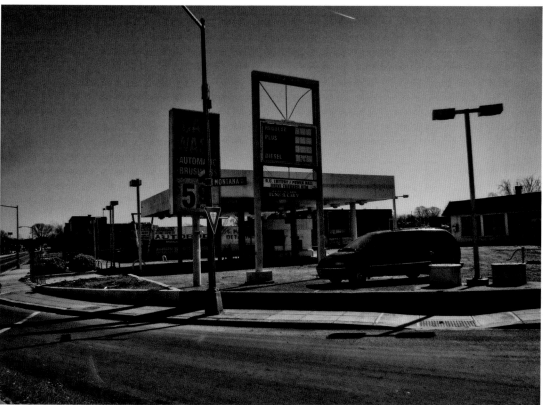

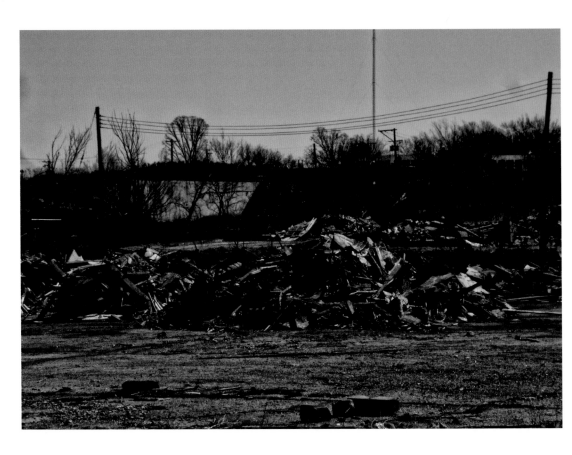

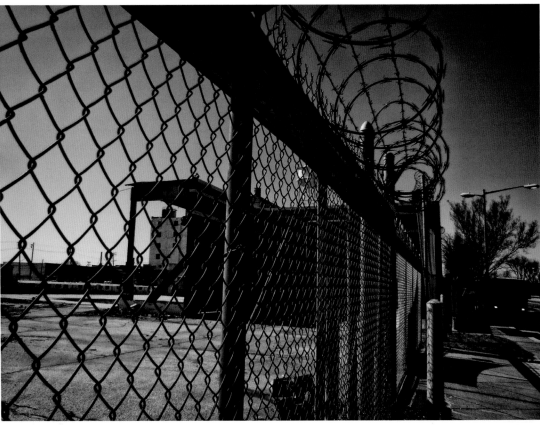

9

ONTARIO THEATRE

Maybe that ruin can't stand vacant forever. Maybe that's not a reasonable way to run a city. But who says the highest bidder is also the smartest man in the room? Who says he knows best what your neighborhood needs next? Bob Dylan wrote that money doesn't talk, it swears. And in DC, the developers have some of the dirtiest mouths around.

Take the vacant Ontario Theatre, originally opened in 1951. Sure, the market has changed—these days, people see movies in 3D-ready, shopping mall-centered

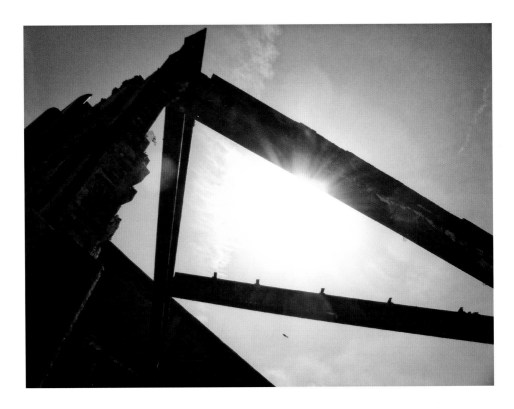

megamultiplexes, when they see them at all. It's a far cry from the sixties, when *The Sound of Music* made its DC premiere here—and then played for the next two years straight on the Ontario Theatre's one screen. That's crazy—one movie on one screen sustaining a business for two years. No way, anymore.

But is Adams Morgan really better off with another six-story luxury condo building in place of the defunct Ontario Theatre? Will it make the neighborhood a more distinct or special place to live in or visit? Is it a responsible addition to this historically mixed-income neighborhood's array of housing options? Or is it just another symbol of the creeping gentrification that has extended ever westward like the sullen, slow hand of certain cultural death since the Green Line reached Columbia Heights in 1999?

The developers won support for their plans as they so often do, with a promise that the new structure set to inhabit this space will include a superficial nod to its history. The new condos at 1700 Columbia Road will retain features deemed architecturally significant by someone who supposedly knows. The iconic sloping marquee was removed early in demolition and will be returned in the final stages of construction, recontextualized beyond all sense.

But let's get real. Let's be frank. The developers who conceived this plan don't care about the history of the Ontario Theatre. They don't care about the theatre's close ties to Adams Morgan's heritage as a Hispanic enclave—it became DC's premiere Spanish language cinema during the 70s. They don't know or care that during the early 80s, DC's own Minor Threat played a show here on one of the nights when it wasn't screening a veritable A-list cavalcade of B-movies.

Instead, their empty gesture—their nod to history—will mystify future tenants. No one will see a marquee. They will look upon the bended girder over the entrance of their glass and steel building with the same sense of muddled perplexity that modern man musters when confronted with Stonehenge. From whence did it come and what does it mean, this oddly arranged protrusion reaching tentatively to the sky like some arm, akimbo and ready to receive a prophesied parcel from heaven?

I am cynical about their plans because they are cynical about you and yours. They care little about what is right for your neighborhood, and more about identifying which revenue streams are left underexploited by existing development. You are a consumer, and your neighborhood is a market. To borrow a vulgar turn of phrase often employed by developers, your entire neighborhood is a "mixed-use development."

But consider this: You and all of the people who lived in Adams Morgan before you have ultimately decided which schemes thrived and which ones died. That truth is

written in the cityscape around you, in the ruins of failed things and ideas whose time came and went. You can have parks and greenspace and bike lanes. You can have schools, community centers, or churches. Yes, you can even have a vacant building, standing beautiful in ruin, perhaps awaiting a use suited to its form. Adams Morgan has examples of each, and many of these development decisions were predicated on the notion that there are other more ephemeral, but equally valid measures of real estate value than just the dollar.

Adams Morgan, like so many Metro-accessible neighborhoods, already has more than its share of interchangeable luxury condos. If that trend continues, how many of the shambling old folks or clearly disabled neighbors who live on my block will be displaced by rising property values—rent control be damned? How many of the local businesses— the storied nightlife that attracts so many visitors to the neighborhood, the cool record shops on 18th Street, the dive restaurants that scare the casual diner but reward the in-the-know locals—can maintain their profit margins in the face of skyrocketing rent? Maybe if we're lucky the enhanced property values will even attract a Panera Bread.

Which development enriches the neighborhood, and which enriches the developer?

When I think of Adams Morgan living, I think of the century-old townhouses, peeling paint, and creaky floors which speak to the history of the neighborhood. The marketing papers this over with phrases like "up-and-coming."

I often want to ask the residents of bland structures like the new one that sits on top of the Ontario Theatre, which add to the neighborhood's population while taking away from its character—did you *really* want to live in Adams Morgan, or underneath it all, would you have been equally happy in a prefab unit near the expressway, somewhere where the Red Line and the cornfields meet? That is equally up-and-coming. Did you like my neighborhood, with all of its diversity and history and everything that makes it special, or just its proximity to a Metro stop?

In the end, maybe the developed Adams Morgan—one where the Ontario Theatre is forever leveled—isn't really right for anyone except the developers.

Party on in your contemporary luxury condominium, with affordable prices—two bedrooms starting in the mid $600s. And remember to tell your new neighbors that the ugly awning thing spoiling the modern building is upcycled from the Ontario Theatre, for some reason …

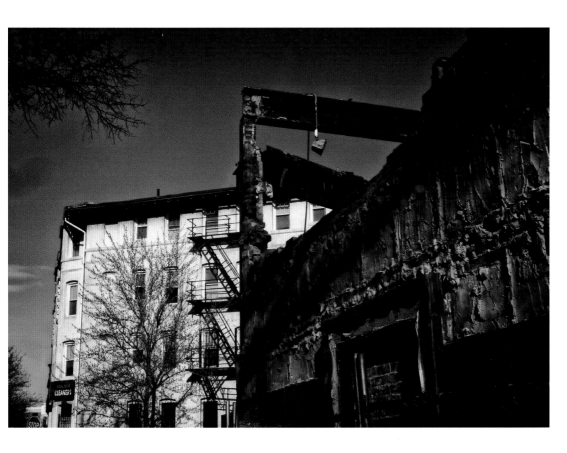

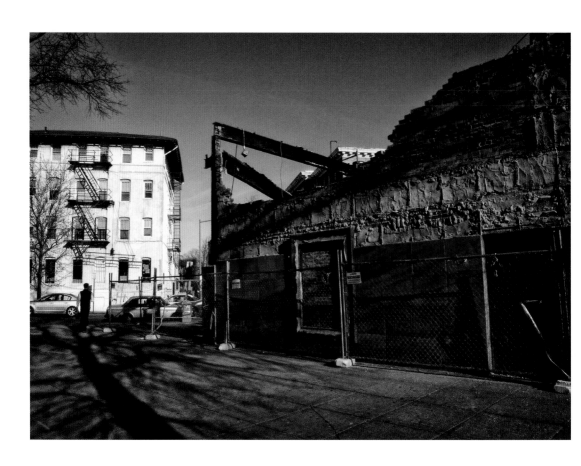

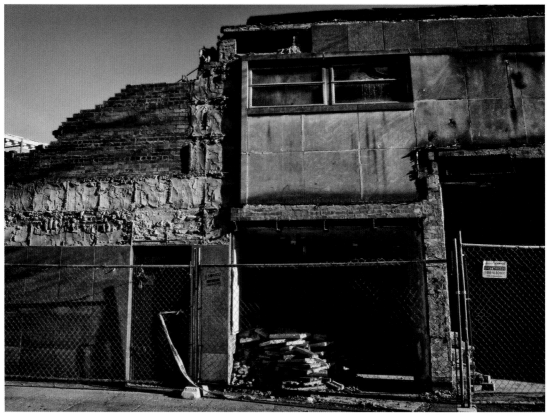

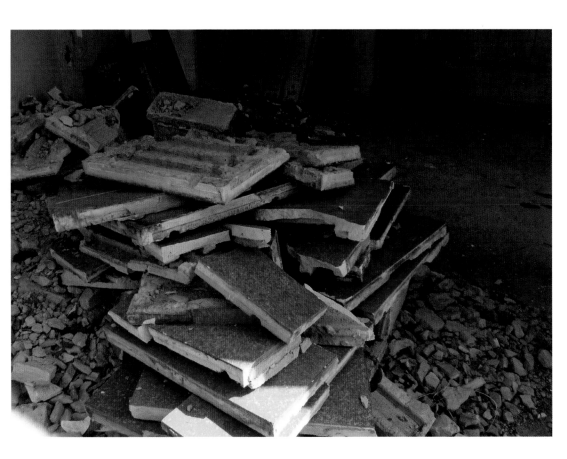

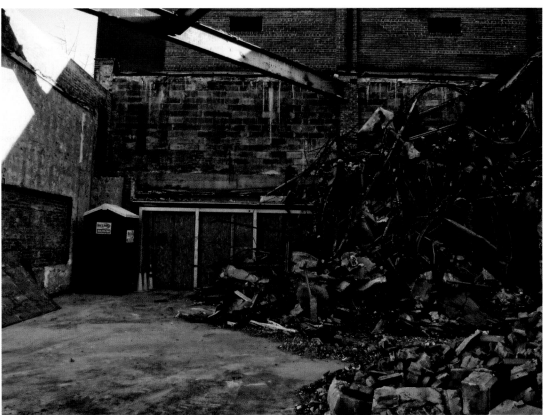

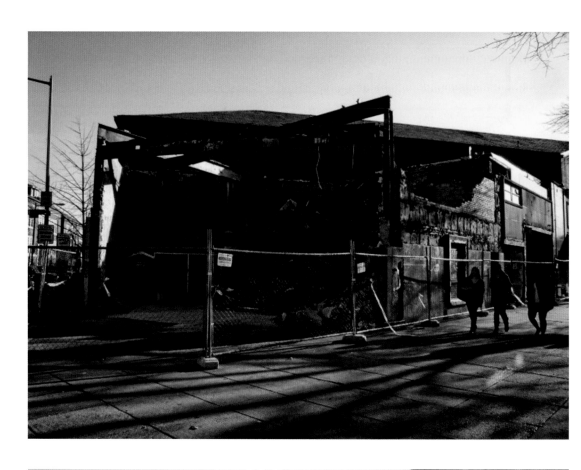

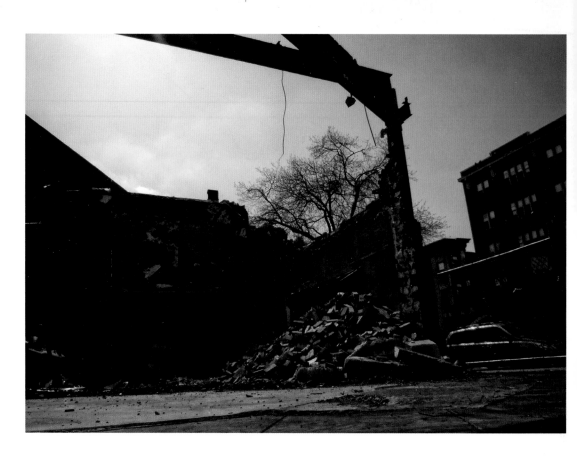

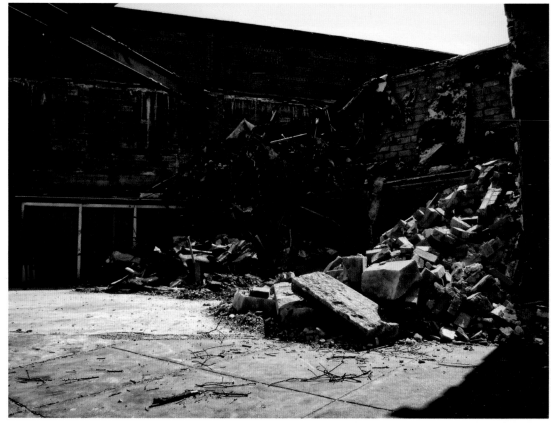

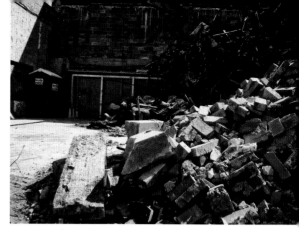

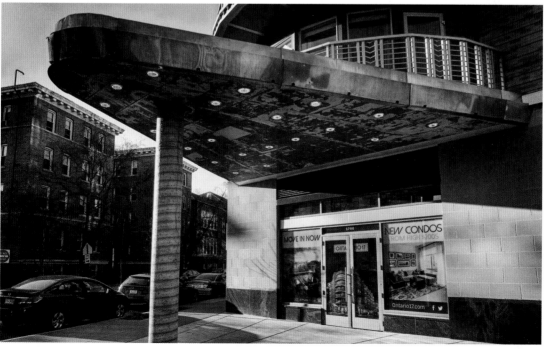

10

TIDEWATER LOCK

O
n the banks of the Potomac River just west of the Watergate lies a sleepy stand of
trees, forgotten on the margins of the monumental architecture of DC. In its shade, the
shallow waters of Rock Creek empty briskly into the listless current of the greater river,
flowing through the splintered sieve of a ruined dam—the sepulchral remains of the watergate,
tidewater lock. One hundred and fifty years ago, this was the terminus of the Chesapeake &
Ohio Canal, the metaphorical vascular system—the coursing lifeblood—of a small working-class
port called Georgetown, which staked its fortunes on feeding the growing appetites of the
neighboring capital. As the wreck in this quiet grove ably demonstrates, there is little so lost on

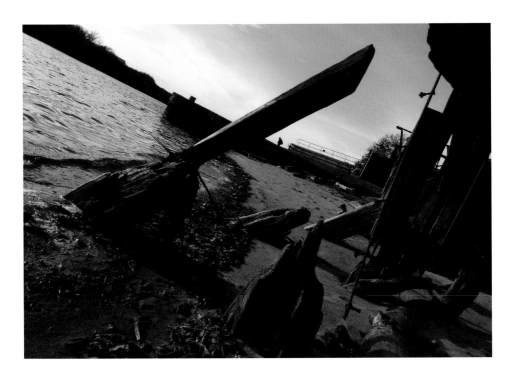

modern Washingtonians as the District's former dependency on water for commerce.

This dependency is built into the very map of the city. For example, what is today Constitution Avenue was once a canal linking the Potomac and the Anacostia, designed to ease the delivery of supplies like coal to federal buildings. Going even further back, the site of the District itself was chosen for its position adjacent to the Potomac, which allowed easy access to Atlantic trade—including grain, manufactured goods, and slaves—via the Chesapeake, but far enough inland to take advantage of the defensive opportunities offered by the river's winding course. In fact, DC sits on the last navigable stretch of the Potomac; Great Falls is exactly what it sounds like, barring both merchant vessels and warships from traveling any farther upriver.

Hence, the 1820s saw crews breaking ground on the C & O Canal—an overly ambitious scheme to bypass those unnavigable sections of the Potomac, linking the Ohio Valley to the Atlantic Ocean—which began and ended here at the tidewater lock. The lock raised the level of Rock Creek some three feet, allowing the low draft flatboats room to maneuver, turning around in preparation for their return journey inland after offloading and loading cargo at Georgetown.

One hundred and fifty years ago, this site would have bustled with the beasts of burden who kept the flow of trade along the stagnant waters of the C & O moving—ropey stevedores and roustabouts, wiry mule drivers in worn out shoes, and dusty teams of mules swatting flies from their backs with nappy tails, fresh off the towpath, clamoring about, making this one of the busiest parts of town. Now, standing near the rotted lock, all you can hear is the undifferentiated and consuming hum of the Rock Creek Parkway and the occasional boat launch from nearby Thompson Boat Center. As I stand here with my feet in the sand, my only company is a lone fisherman casting in the Potomac. Today, in the age of rail and road, you'd be hard pressed on most days to find anything other than recreational craft in the waters around Washington.

Time has mangled the tidewater lock and its adjoining waste weir, designed to mitigate surges of water in and out of the canal system. The eastern portion of this has all but disappeared, its wooden frame almost completely consumed after resting in the water for more than a century. The western portion has fared only slightly better, probably due to the accumulated sediment of all those years—the sandy beach on which I now stand. When the moon is right, the tide rises to cover this tenuous bank. For now, the weir stands dry as the porous, desiccated rib cage of some ancient and forgotten behemoth—a wooden buffalo, say—long extinct and of a very different time. Esoteric, but still remembered by an interested few.

May we all fare as well.

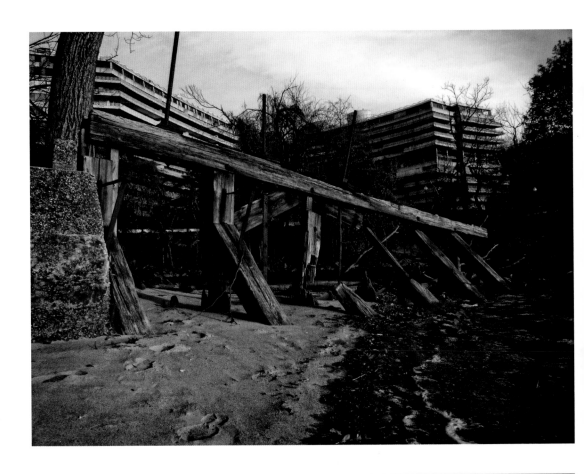

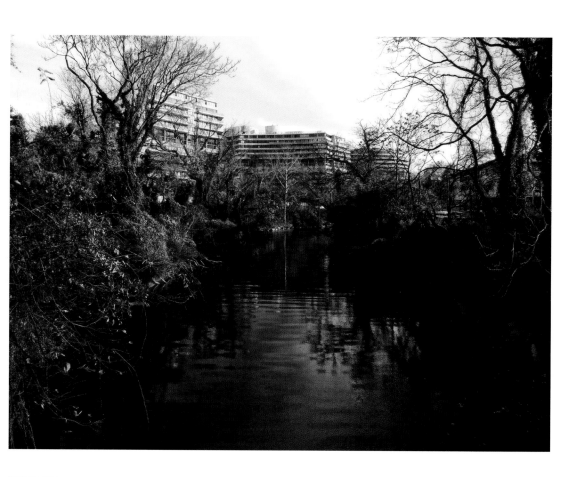

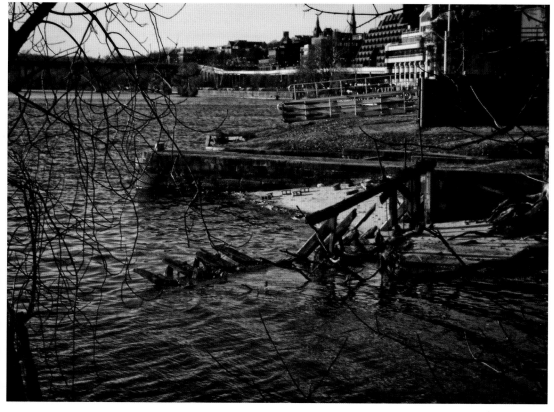

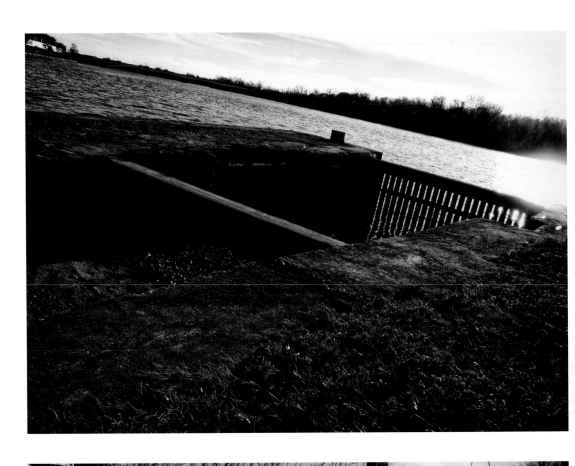

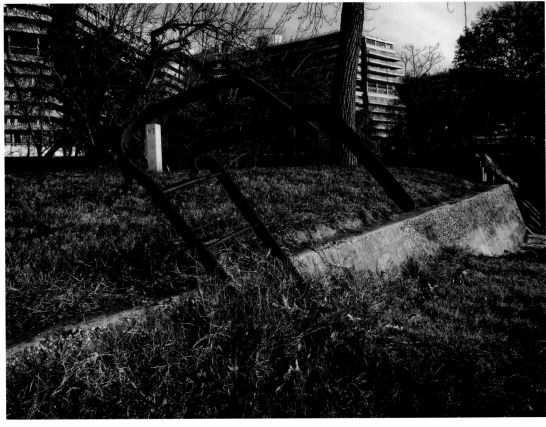

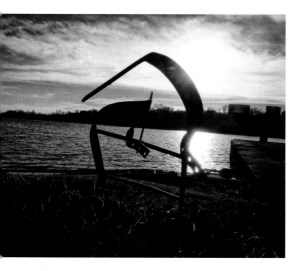

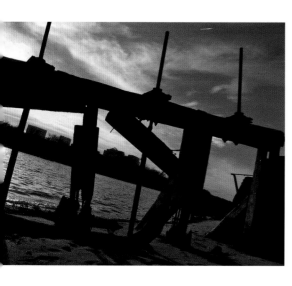

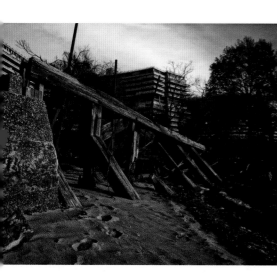
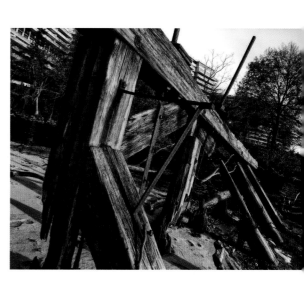

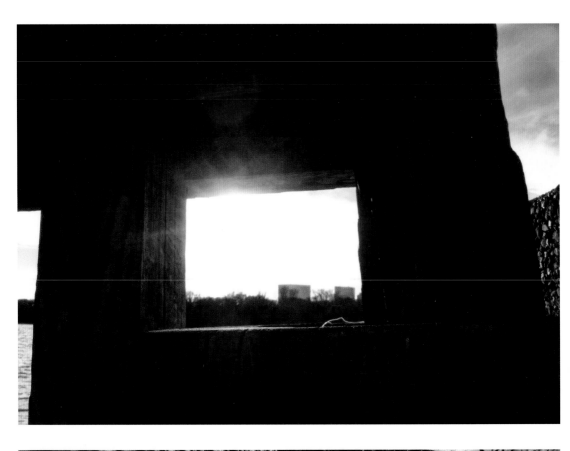

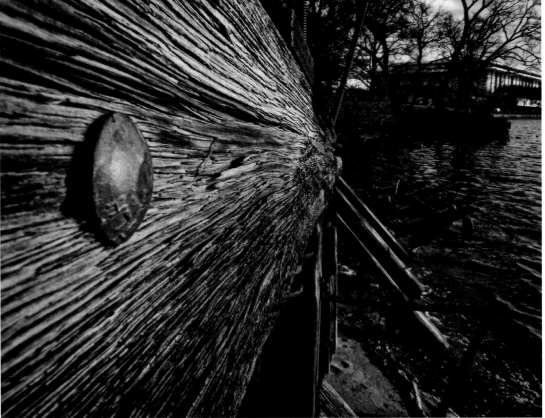

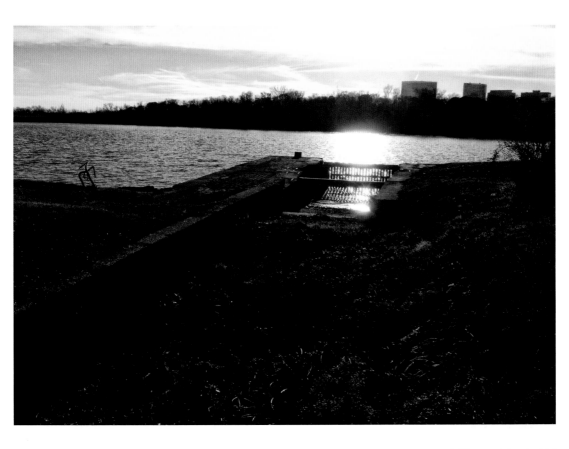

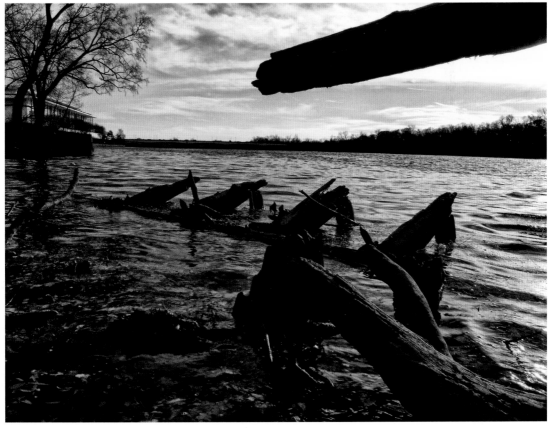

11

UNITED BRICK CORPORATION

T he first thing you probably notice are the ominous, alien domes on a broad and barren, weed-cracked slab. There used to be twelve of these in all, but only a few remain intact, like storage tanks for some antebellum space program, like sacrificial altars to a long forgotten god. Above it all, a lone smokestack rises, a mysterious sentinel of faded industry, a Panopticon in the harshest of labor camps. A washed-out gravel road brings you to a chain link gate, padlocked against trespassers, mangled to suggest that at least a few have not been deterred.

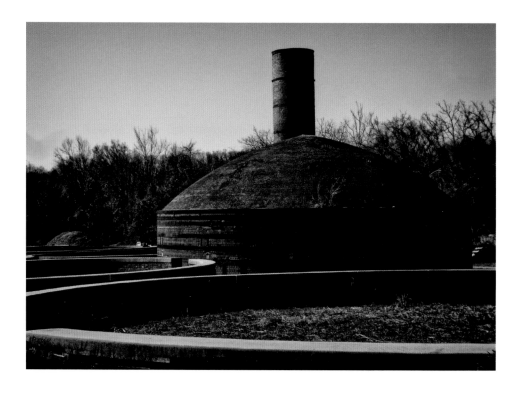

This isn't the site of some lost penal colony. But you'd be forgiven for not knowing. There's no plaque to clue you in and no historical marker. And maybe that's the most confounding thing about it—this is a registered historical site located within a well-funded park. As such, nothing suggests America's casual indifference to the past quite like the shambling remains of the United Brick Corporation.

This former industrial site is an anomaly on the grounds of the carefully manicured National Arboretum. Dating back to the late nineteenth century, the United Brick Corporation was among the largest of numerous brick manufacturing concerns in Washington, many of which were literally operated out of the backyards of District residents. In a former life, those distinctive domes that first grabbed your attention were beehive furnaces used for firing carefully stacked bricks, a process that, depending on the weather, could take a full week.

The workers who carried out the spine-crushing labor of carting ton after ton of brick one load at a time, back and forth between the drying sheds and the domed furnaces a hundred feet away, played an integral part in shaping twentieth-century DC. The resulting bricks are today found in Lafayette Square, the National Cathedral, and the Broadmoor on Connecticut Avenue. In a way, the forgotten United Brick Corporation, which drew its raw clay from the banks of the nearby Anacostia, has insinuated itself quite tangibly into the city's DNA, helping to transform the bucolic District of the nineteenth century into the urban landscape we know today.

In the years following World War II, construction techniques turned away from brick to favor the clean lines and economy of concrete, and in 1972, the faltering United Brick Corporation was shuttered. In 1976, the already crumbling factory was transferred to the auspices of the United States Department of Agriculture and incorporated into the grounds of the National Arboretum.

Actually, from my perspective standing on the far side of a locked gate, the word "incorporated" is perhaps an overstatement. The Department of Agriculture is not in the business of preservation or presentation of history; rather, its mission here is the cultivation and presentation of various types of flora. The brickyard is set apart quite distinctly from the rest of the campus. The administrators seem uncertain what to do with this windfall of idled industry. No doubt their lawyers advised the high fencing around the site, as well as the wide-open space between the fence line and the structures within—all the better to spot potential explorers. In addition, the adjacent parking lot near the Arboretum's New York Avenue entrance seems to be a favorite spot for cops winding down the final hours of their shift. On each of four visits, there has been at least

one cop car present—sometimes several—a situation not exactly conducive to hopping the fence in flagrant disregard of the multiple U.S. government "No Trespassing" signs posted around the perimeter. The United Brick Corporation may as well be stowed in bubble wrap.

There were once eight smokestacks standing some forty feet tall, including six older rectangular structures, but now the only trace of those are the cracked foundations scattered throughout the grounds. Closest to New York Avenue, you'll find a long, low drying shed once used for storing unfired bricks before they made their way to the nearby beehive furnaces. Each of its thirty-eight tunnels—just like the entryways to those distinctive domed beehives furnaces—has been shuttered with thick, wrought iron bars designed to protect any would-be explorers from the questionable structural integrity of this century-old site.

The rest of the site is used to store mulch and gravel, presumably for routine upkeep in the arboretum grounds. I guess I don't know for sure, but I have a feeling that this is hardly what those who sought to preserve these grounds had in mind when they applied to the National Register of Historic Places in 1977.

But it's what happens when you leave the bureaucrats and lawyers in charge.

Ask Magellan, Neil Armstrong, or anyone else—mankind is at its most inspirational when the insurance premiums are sensible.

What a waste of good ruins.

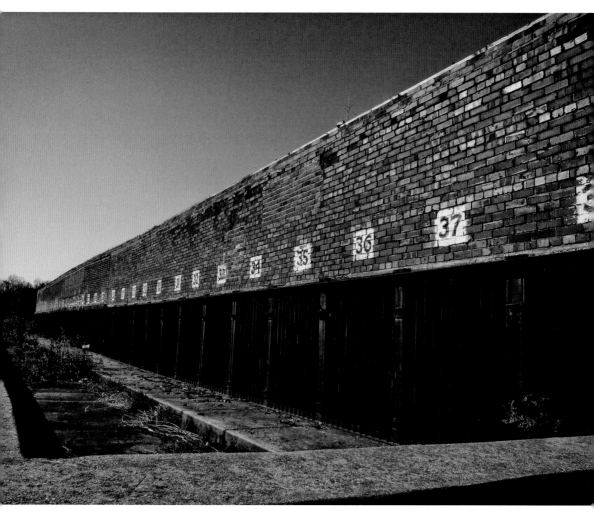

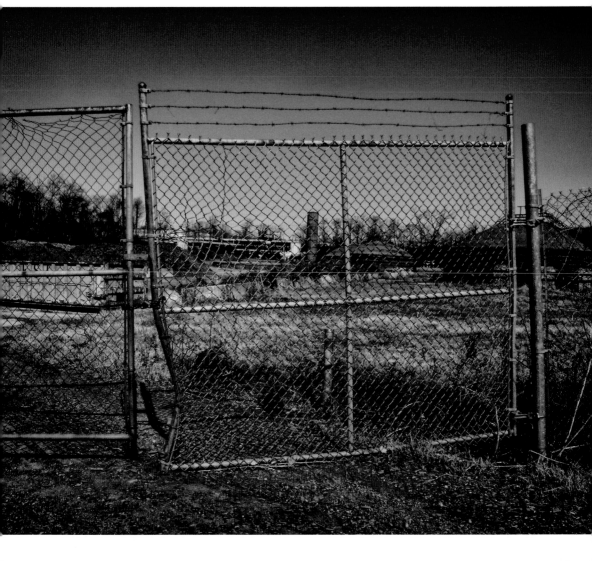

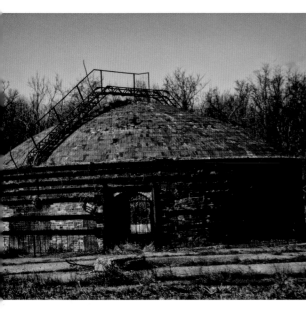

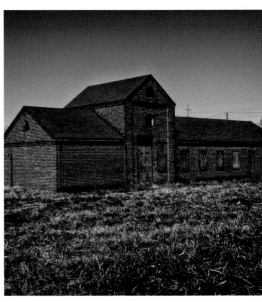

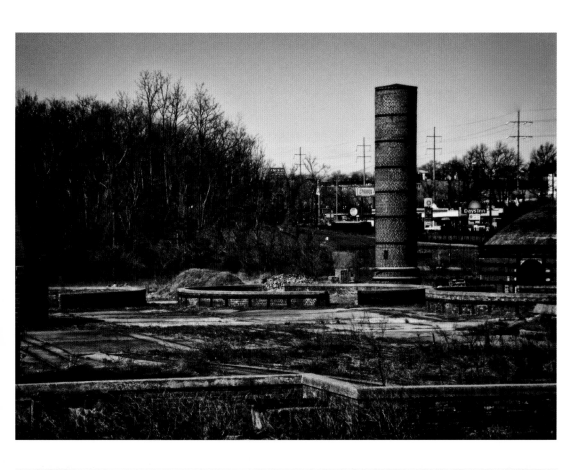

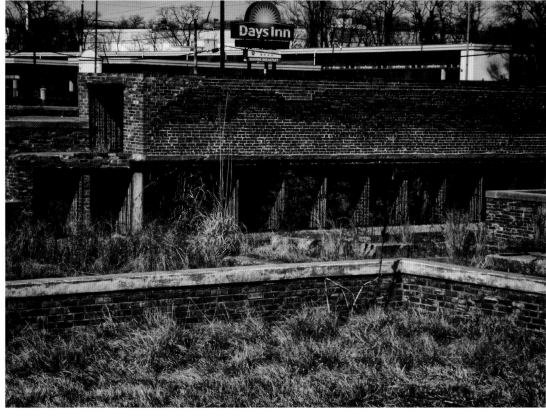

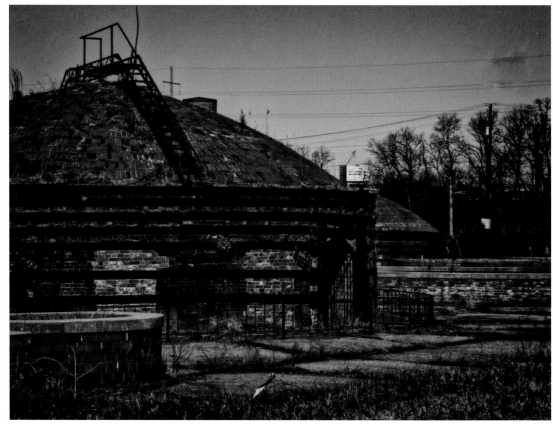

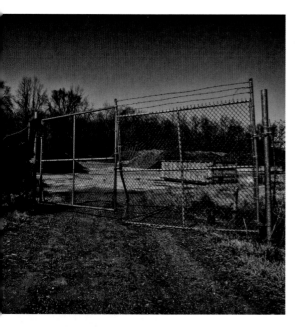
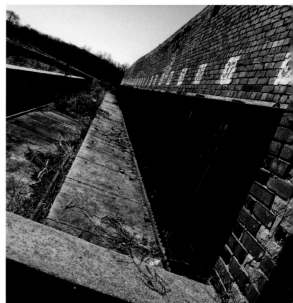
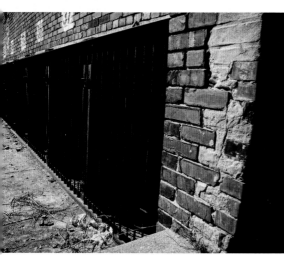
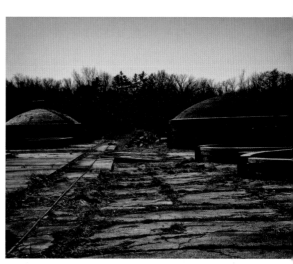
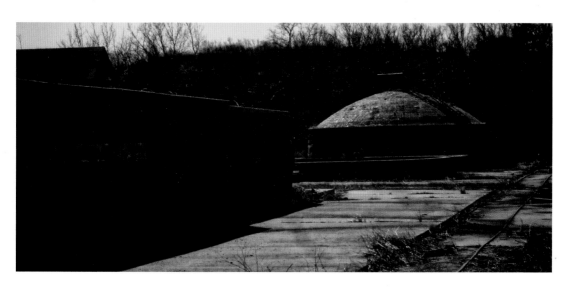

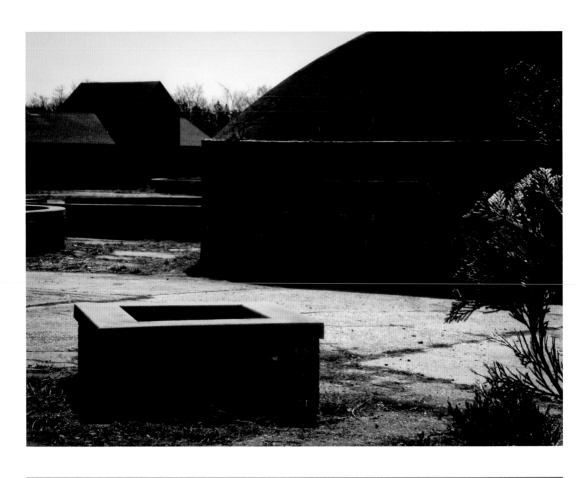

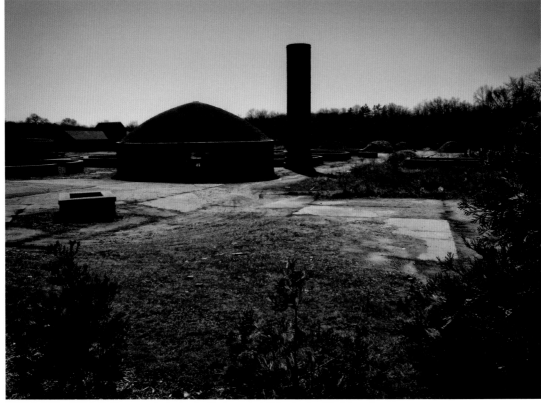

WASHINGTON & GREAT FALLS ELECTRIC FALLS ELECTRIC RAILWAY

I like to explore. To see things from every angle. To really understand how it all fits together. I want to see a bridge not just from the top, but from underneath as well.

Consequently, I have a propensity for stumbling into the hiding places of people who more often than not probably just want to be left alone. When you wander off into the woods, you find that the margins of society are a lot closer than you might think.

It's a sunny day in late May. Memorial Day weekend, to be precise. There's hardly a soul to be seen on the campus of Georgetown University. But that's not my final destination; I just needed a rack to stash my bike before I traipse into the woods behind the school, looking for some place even more abandoned.

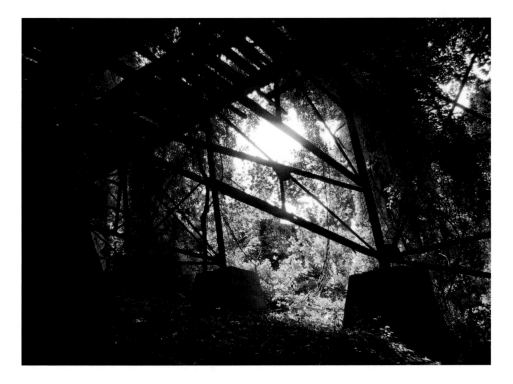

I haven't told any friends or family where I'm going, because I don't exactly know myself.

That last fact suddenly seems relevant as I come into a small clearing in the woods and find myself in the midst of what is obviously an improvised campsite. This is the kind of improvisation that results not from whimsical spontaneity, but from abject poverty—a small tarp, a rusty chair with chewed up upholstery, beer cans. The components of this camp have the cast-off look of stuff diverted from a dumpster.

No one seems to be around at the moment, but I can tell you that if the positions were reversed and I found someone snooping around in my home, I might be more than a little protective. That's a kind of adventure I don't need. So I decide to backtrack and rethink my attempt to trace the route of the Washington and Great Falls Electric Railway, a commuter rail system that once ran through here on its way to suburban Maryland. This was back in the day when the suburbs were still new thing, a phenomenon made possible through mechanized transit like this former modern marvel.

It turns out that I never even had to try so hard to find one of the last remnants of this precursor to the Metro. Its most prominent decaying trestle is easily visible from Canal Road. And there's a busy foot path that runs beneath it—my once too-intimate exploration has become a somewhat public spectacle.

The railroad's old right-of-way is intermittently apparent well into the Maryland countryside. Three more trestles lay crumbling in the woods and along a multi-use trail that partially traces the route. This is all before the weary explorer reaches the railway's former terminus in Cabin John; what was once an easy train ride is now a decent hike or bike ride.

A few weeks after my visit to Georgetown, I call on another of these trestles, this time spanning Walhonding Brook. It's a little more secluded than the Georgetown trestle, though it essentially resides in a small wooded median between two busy roads. It's a little more overgrown than the Georgetown trestle, but I am able to cautiously scale this one and get a good view of the weed-covered track on top. Georgetown may have a taller structure, but there's more thrill here in the woods outside of Glen Echo—it's more secluded, and much closer to just me and the collapsing remnants of the past, and here we can really get to know each other.

For years, DC area transit was a hodgepodge of these half measures, stitched together but never a finished thought. Multiple operators, multiple modes, and multiple payment schemes—the outcome of a more or less free market approach to public transit. The Washington and Great Falls Electric Railway was an entrepreneurial venture susceptible to profit margins and the volatilities of demand. Its ultimate closure is attributable in large

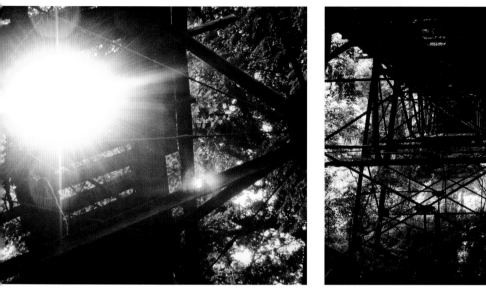

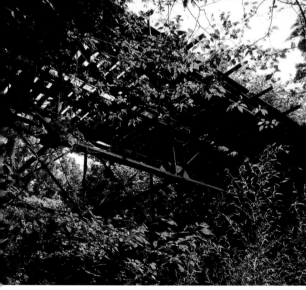

part to the rise of the automobile, which was marketed to appeal to the American sense of independence—a quality lacking in the collective, rail-bound atmosphere of a train.

Today, the publicly-owned Metro certainly doesn't lack for ridership, but it is maligned and cursed, affectionately or not, for its state of disrepair, sometimes charming and sometimes deadly. Frayed carpets are less serious than frayed wires, but on any given day there is a chance you could encounter both somewhere in the system. In contrast to the Washington and Great Falls, the Metro was brought forth by a few visionaries who decided that mass transit was a public good—one that alleviated traffic and air pollution, diminished the demand for parking lots and highways in our urban landscape (both of which were once planned for the National Mall!), and ultimately made the city of Washington, DC a more walkable, vibrant place.

The Metro is chronically underfunded, perhaps a consequence of a resurgent car culture or an aversion to so-called "wasteful government spending." As for transportation, ridesharing is the latest buzzword, along with "on-site parking" at many of the District's hottest mixed-use developments.

Neither of those are inherently bad things, mind you, but it is worth remembering that even if you rarely or never ride the Metro, you are in its debt. Every rider is one less driver on the road, one less freeway carving through your neighborhood, one additional free parking space on your street, or a lung just slightly less saturated with exhaust.

I'd call most of those things priceless. But remember, you get what you pay for. Or in this case, what your elected officials don't pay for.

The key difference between the Washington and Great Falls Electric Railway and the Metro is that one was conceived to turn a financial gain, and the other was designed to render up a public good over anything else.

As I stand upon the skeleton of a century-old electric railway trestle, built by capitalism to meet a demand that never materialized at profitable levels, I wonder which will turn out to be the more sustainable experiment.

The present, the here and now, is little more than a bridge that links the past to the future.

And as I mentioned, I like to see that bridge from all angles.

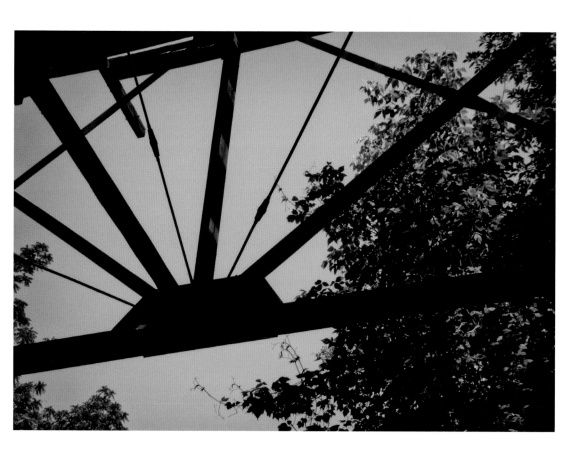

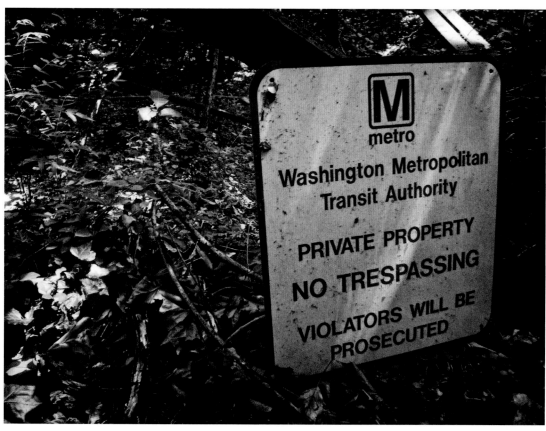

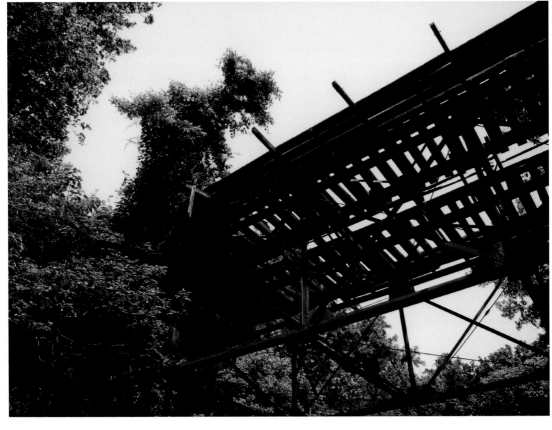

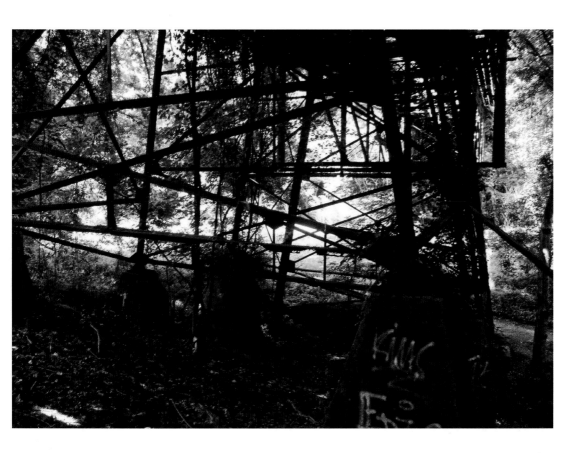

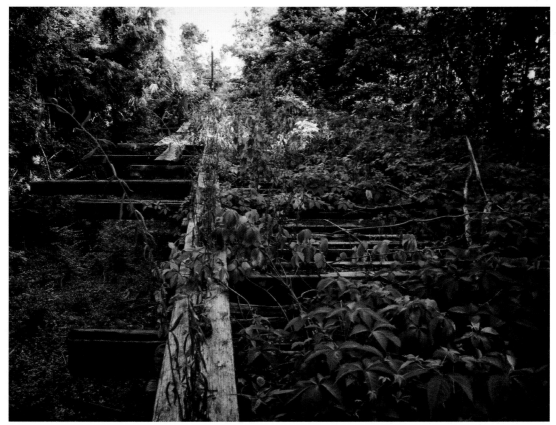

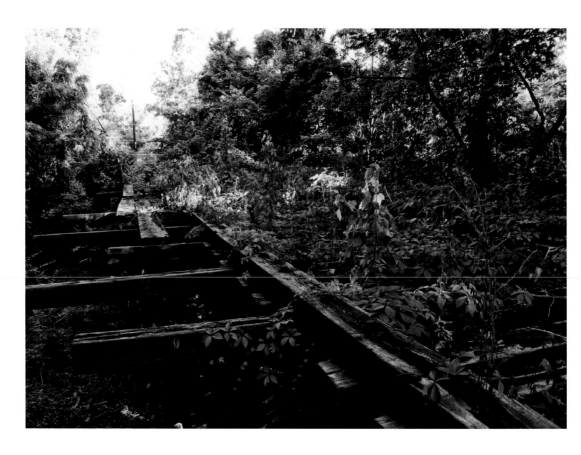

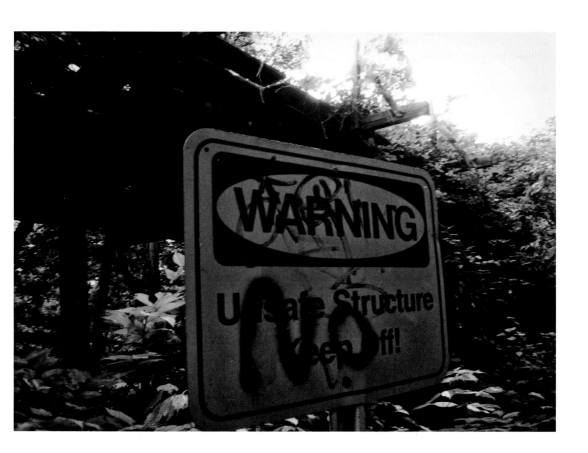

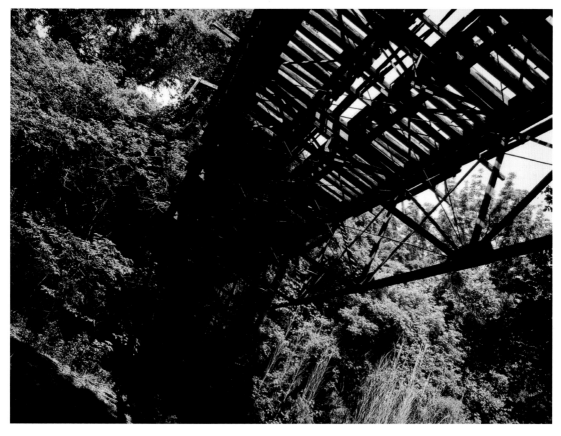

13

WASHINGTON, ABANDONED WITHOUT END

If we're being honest, our buildings start to slip away from us the minute that first coat of paint dries.

Sure, we patch and maintain quite earnestly while times are good, but when things get tough, without fail, we humans give up on our buildings. In that sense, they are often abandoned in spirit long before they are vacant.

Consider that creaky floorboard or the dripping pipe you keep meaning to fix, and ask yourself—when will that moment of surrender come for the home in which you're sitting? Has it already passed? And what about the building in which you work? Consider the

dizzying events that tear at the ideological fabric of our nation and ask the same question of iconic symbols like the Capitol Building or the White House. These can seem timeless, like they will survive forever in their current form. But like the Forum or the Acropolis, which seemed the same at the heights of their glory, they are anything but eternal.

At the heart of it, these are some of the most essential questions that I find myself pondering after years of exploring the urban ruins of Washington, DC.

At some point, each of the buildings featured in these pages represented someone's best hope for the future—and at some point, each one became a dream discarded, like some disowned child or a hard-fought battle finally given up for lost. The Aqueduct Bridge Abutment, Forest Glen Seminary, the Washington and Great Falls Electric Railway—they are all orphans with a story to tell, tragic heroes of an opera written in rusted steel, cracked concrete, and rotted wood. It's a symphony of mixed emotions, bittersweet but compelling for anyone who cares to listen.

And we the living are left to our contemplation, if we are able to hear their faint songs over the tumult of the present.

See you out there, in splendor and ruin.

ABOUT THE AUTHOR

Thomas Kenning is an author, educator, and adventurer. He has written extensively about Washington, DC for his own blogs and on a freelance basis. Mr. Kenning is the creator of the award-winning Openendedsocialstudies.org, a library of free lesson plans and travel writing designed to foster a sense of wonder about the world and our place in it. When he is not travelling to some far-flung corner of the Earth, he resides with his wife and daughter (a DC native!), planning his next improbable adventure and trying to leave the planet a little bit nicer than he found it.